For Russell —
With many thanks and best
wishes for happy hours of
painting (and pouring) fun.
Continued success!
Jean H Grastorf

POURING

LAYERING TRANSPARENT WATERCOLOR

LIGHT

Jean H. Grastorf

NORTH LIGHT BOOKS
CINCINNATI, OHIO
www.artistsnetwork.com

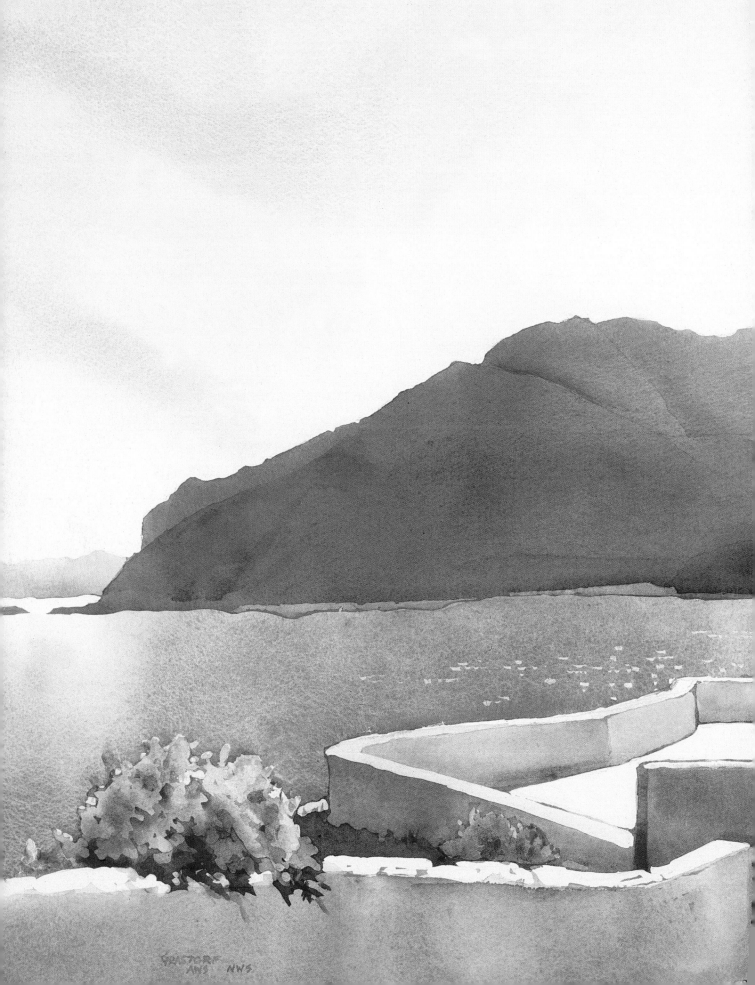

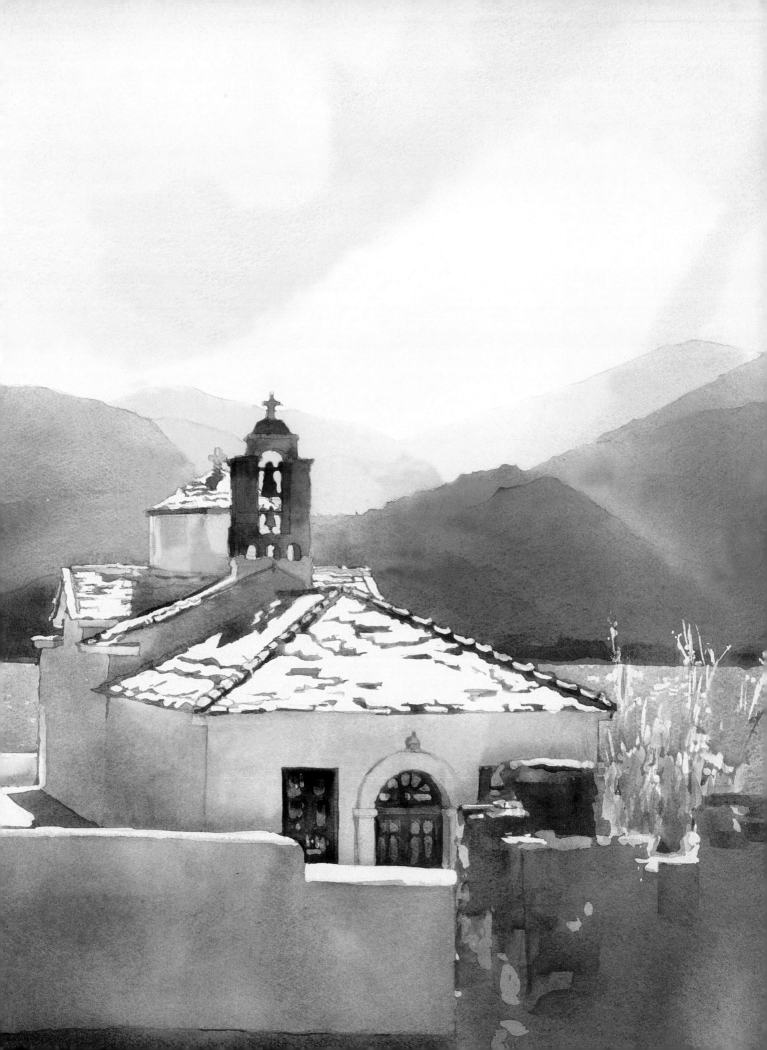

ON PAGE 2:

SKOPELOS
28" × 36" (71CM × 91CM)
COLLECTION OF ROB AND JEAN WILHELM

ON PAGE 5:

THE OUT-OF-TOWNERS
20" × 28" (51CM × 71CM)

Pouring Light: Layering Transparent Watercolor. Copyright © 2005 by Jean H. Grastorf. Manufactured in China. All rights reserved. No part of this book may be reproduced in any form or by any electronic or mechanical means including information storage and retrieval systems without permission in writing from the publisher,

except by a reviewer who may quote brief passages in a review. Published by North Light Books, an imprint of F+W Publications, Inc., 4700 East Galbraith Road, Cincinnati, Ohio, 45236. (800) 289-0963. First Edition.

Other fine North Light Books are available from your local bookstore, art supply store or direct from the publisher.

09 08 07 06 05 5 4 3 2 1

DISTRIBUTED IN CANADA BY FRASER DIRECT
100 Armstrong Avenue
Georgetown, ON, Canada L7G 5S4
Tel: (905) 877-4411

DISTRIBUTED IN THE U.K. AND EUROPE BY DAVID & CHARLES
Brunel House, Newton Abbot, Devon, TQ12 4PU, England
Tel: (+44) 1626 323200, Fax: (+44) 1626 323319
Email: mail@davidandcharles.co.uk

DISTRIBUTED IN AUSTRALIA BY CAPRICORN LINK
P.O. Box 704, S. Windsor NSW, 2756 Australia
Tel: (02) 4577-3555

Library of Congress Cataloging-in-Publication Data

Grastorf, Jean H.
Pouring light : layering transparent watercolor / Jean H. Grastorf.— 1st ed.
 p. cm.
Includes index.
ISBN 1-58180-605-1 (hardcover : alk. paper)
1. Watercolor painting—Technique. 2. Light in art. I. Title.

ND2422.G73 2005
751.42'2--dc22 2005000935

Edited by Vanessa Lyman
Designed by Wendy Dunning
Production art by Kathy Gardner
Production coordinated by Mark Griffin

ABOUT THE AUTHOR

Originally from upstate New York, Jean Grastorf is a graduate of the Department of Art and Design, Rochester Institute of Technology. She has been a workshop instructor for over twenty-five years and frequent juror, demonstrator and lecturer for state and national watercolor societies. This includes serving as chairman of the Jury of Awards for the 135th Annual Exhibition and a member of the Jury of Admissions for the 138th Annual Exhibition of the American Watercolor Society. Jean also holds signature memberships in the National Watercolor Society, Transparent Watercolor Society of America, Rocky Mountain National Watermedia Society, Watercolor West, and the Southern, Florida and Georgia watercolor societies.

Jean is a frequent contributor to watercolor and art periodicals, including *Watercolor*, *Watercolor Magic* and *International Artist*. Her work appears in *Splash 3, 4, 5* and *8* (editor, Rachel Wolf); *Best of Watercolor* and *Best of Watercolor 2* (editor, Betty Lou Schlemm); *Easy Solutions: Color Mixing* by M. Stephen Doherty; *Watercolor Mixing: The 12-Hue Method* by Christopher Willard; *Celebrate Your Creative Self* by Mary Todd Beam; *In Harmony with Nature* by Maxine Masterfield; and *Exploring Color* by Nita Leland.

Jean presently lives in St. Petersburg, Florida, with husband Bill and a Burmese cat named Katie.

METRIC CONVERSION CHART

To convert	to	multiply by
Inches	Centimeters	2.54
Centimeters	Inches	0.4
Feet	Centimeters	30.5
Centimeters	Feet	0.03
Yards	Meters	0.9
Meters	Yards	1.1
Sq. Inches	Sq. Centimeters	6.45
Sq. Centimeters	Sq. Inches	0.16
Sq. Feet	Sq. Meters	0.09
Sq. Meters	Sq. Feet	10.8
Sq. Yards	Sq. Meters	0.8
Sq. Meters	Sq. Yards	1.2

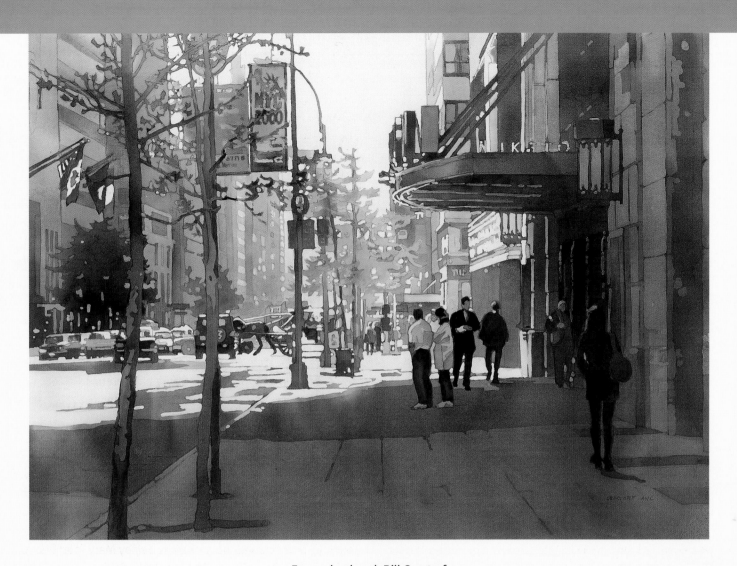

For my husband, Bill Grastorf:
Without his help there could be no book.

ACKNOWLEDGMENTS

In writing a book it is a necessary pleasure to rely on the talents of others. Their willingness to share these talents has been a delightful experience for me, and I owe them much gratitude. My first connection with the editors from North Light was acquisitions editor Jamie Markle, who felt there might be something of interest in my pouring method and encouraged me to give writing a try. My always supportive North Light editor Vanessa Lyman gently encouraged me to meet deadlines and straightened out the tangled prose and syntax. I am especially grateful for her ability to sort through my rambling thoughts and dig out the ones that counted.

The students in my workshops who requested this book and asked "just one quick question" gave me a reason to persevere when the computer was balky and the brain was drained. "To teach is to learn twice," French moralist, Joseph Joubert (1754—1824). John and Tina Clifford photographed the artwork with accuracy and dispatch as did my husband, Bill, who did the home studio shots. Our daughter Jean Marie, and her husband, Rob, were always available for advice and comfort.

I would like to thank Linda Baker, Margaret Cornish, Judy Lavoie, Kaaren Oreck, Susan Ossenberg, Gail Peters, Suzy Schultz and Siv Spurgeon. The wonderful works these artists contributed add so much to the book. They are all very talented people and I had the pleasure of seeing several of their paintings completed in my workshops.

While writing, and painting, must at times be solitary occupations, they cannot be done without the encouragement and support of others. The positive attitude and patient listening of Donna Sroka, Margaret Cornish, Sue Ossenberg and Jann Burnett, artists all, made the duration of writing go much easier. You are appreciated.

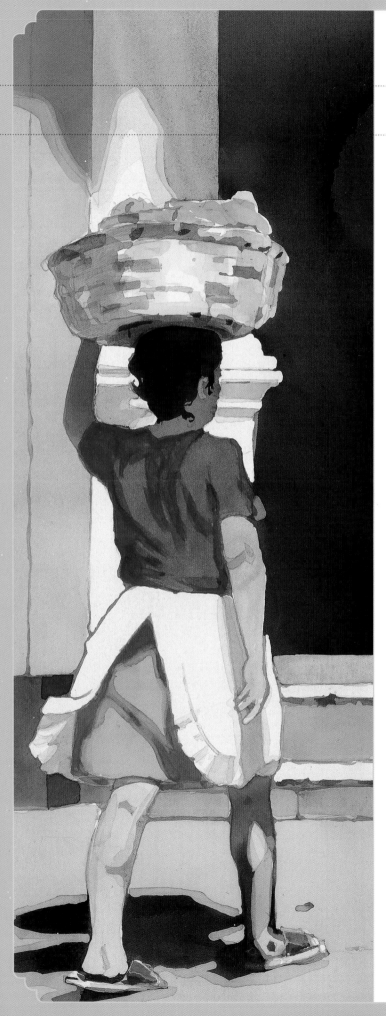

TABLE OF
CONTENTS

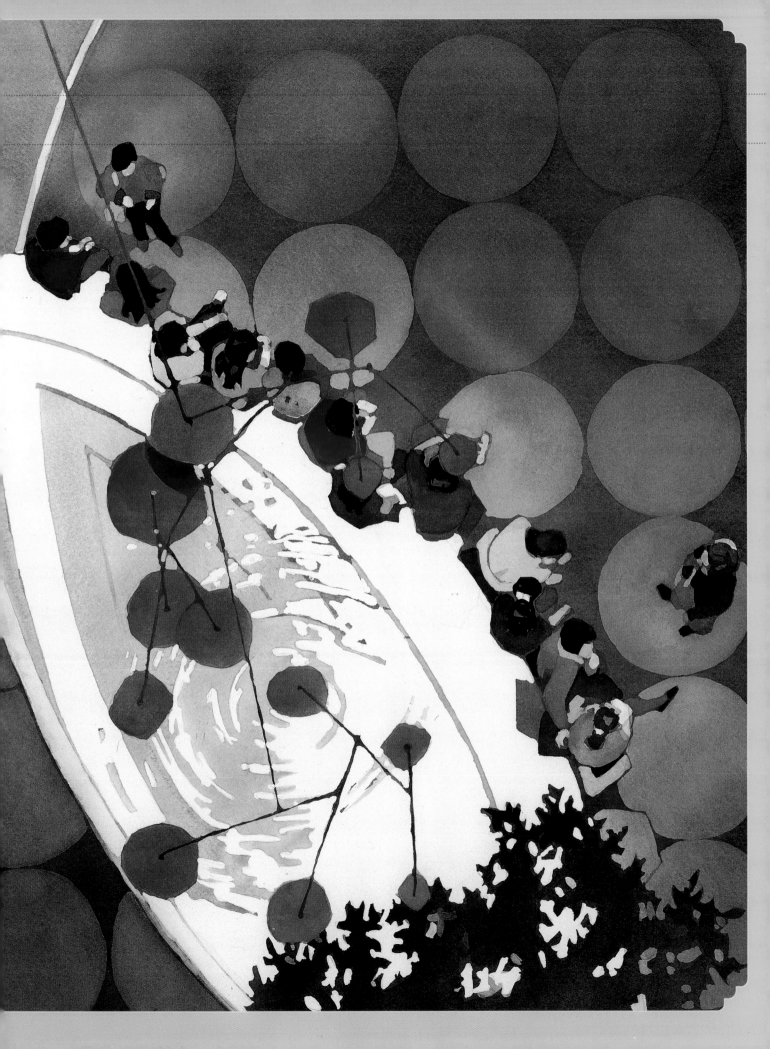

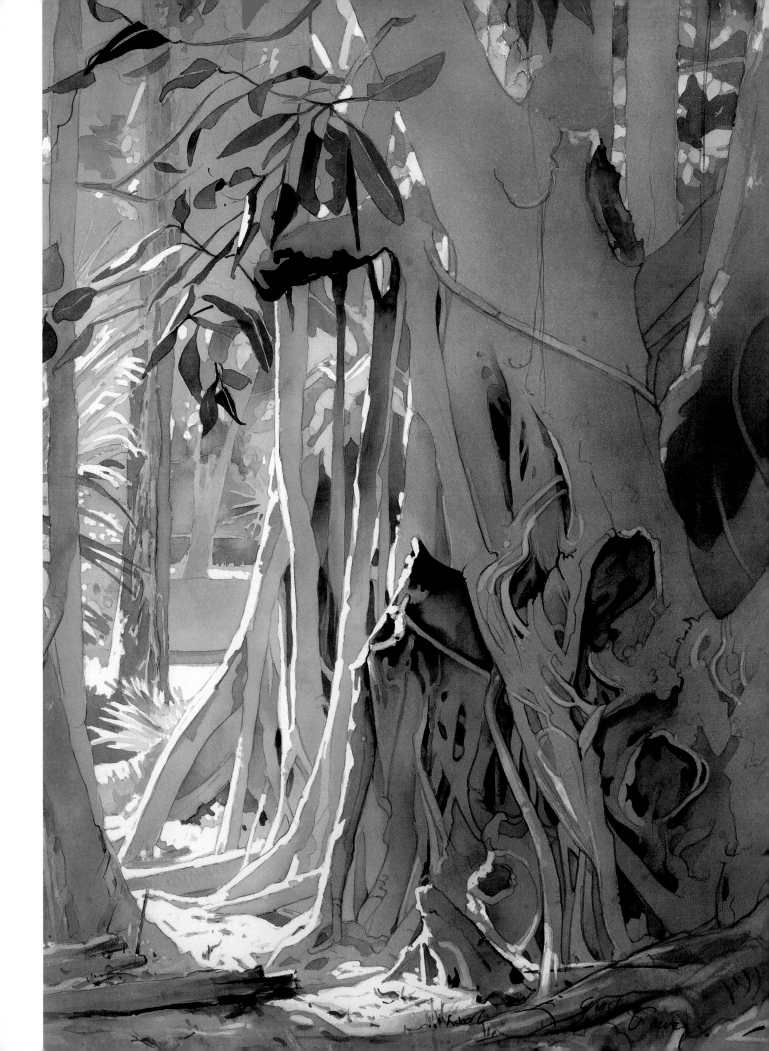

INTRODUCTION: **CAPTURING THE LIGHT**

Washes of transparent watercolor on white paper allow the light to penetrate and bounce back to the eye. Since the influence of light is the foundation of many of my paintings, transparent watercolor has become my medium. By pouring these veils of color, I can capture light.

Watercolor is a medium that has a long history. When an endeavor has a time-honored, traditional approach, overcoming past restrictions and rules can be difficult. Fortunately, most contemporary artists feel no need to limit themselves to materials and techniques of the past. Of course, learning involves taking from what has gone before, and we certainly want to do that. This information will ultimately free us to explore new avenues. Building on solid design principles and color theory allows our creative intentions to flourish.

Reading a book is like taking a trip: Along the way, we encounter new ideas, and some of these ideas may even seem a bit strange. Masking and pouring can be like that. Many watercolorists feel that the use of masking materials may be restrictive, not really true to transparent watercolor.

You are allowed to disagree and try some of the new ideas you'll find on your trip through this book. Using an unfamiliar material, such as masking fluid, will actually suggest several different approaches to painting.

Mixing your pigments in cups and pouring on wet paper may be another strange and foreign encounter. This relationship between "chaos" and "control" is an intriguing one. The "chaos" of poured pigments can safely happen because the "control" of the mask protects the white paper.

Through trial and much error, I've discovered what works for me. Take advantage of this information in the first chapters on supplies, composition and color; it will save you some time and paper. Some "tricks of the trade" regarding paper and drawing preparation may be new to you, so spend some time with them. The color charts and design samples are additional material to look over before you start to paint.

In the final chapter, I included several full-length step-by-step demonstrations to guide you through the process. Once these methods become familiar, it's time for you to "push out the boat" for your own painting trip of discovery.

BANYAN LIGHT
28" × 20" (71CM × 51CM)
COLLECTION OF JEAN AND ROB WILHELM

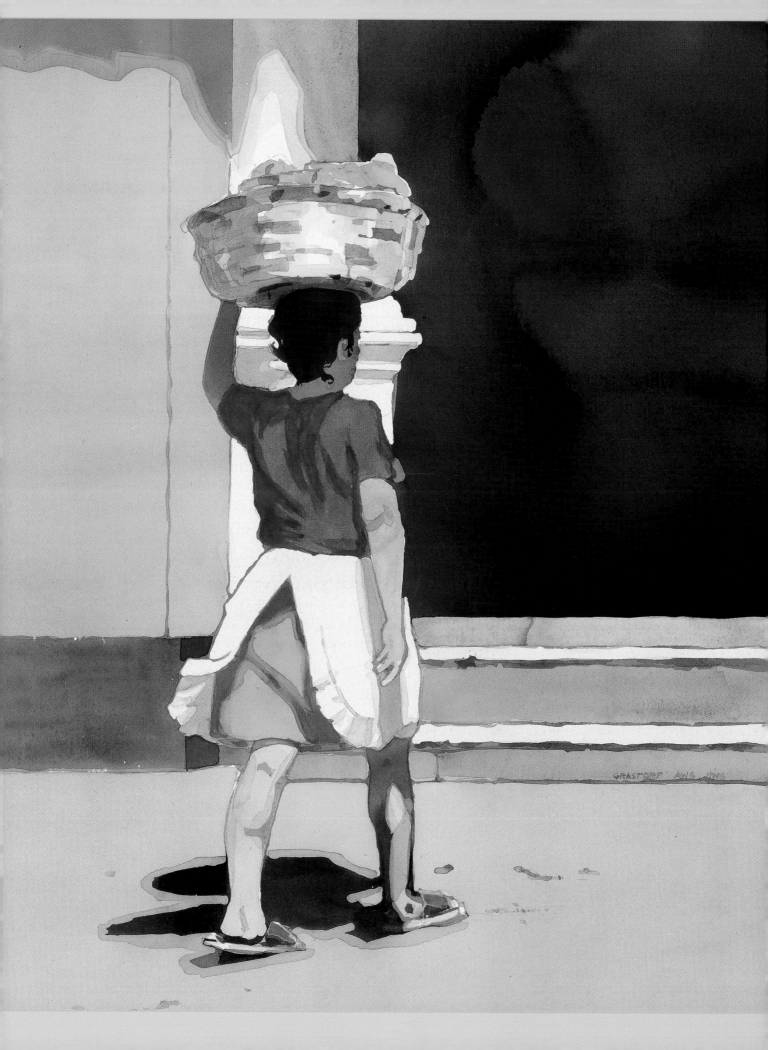

1 PREPARATION:
GETTING STARTED

Pouring watercolor offers unique opportunities to portray light. To me, it is the most direct, personal and sparkling of methods. While we may limit the paint to the three primaries of red, yellow and blue, they will mingle on the wet paper in the most extraordinary ways.

You will use brushes for direct painting, but the majority of the work will result from juicy pigments mixed in separate containers and allowed to flow freely on the wet paper. The materials you need to get started are simple, with a special emphasis on quality over quantity.

Paints, paper, brushes and a few other tools will be your purchases from art suppliers. After that, the fun starts, with trips to hardware, discount and dollar stores to find things for storing, creating texture, pouring, applying and cleaning. I have suggestions based on what works for me, but you'll discover your own favorite tools as you advance through the book. Start with the few basic materials and become familiar with their traits and peculiarities. Art is, after all, about finding your own more personal vision and the best method of sharing it.

STEPPING OUT
28" × 22" (71CM × 56CM)

WHERE DO IDEAS COME FROM?

**ARTISTS PAINT TO CAPTURE A CONCEPT. FIRST IS THE VISUAL REALITY, THE
ACTUAL SCENE AS A CAMERA WOULD RECORD IT.**

This sparks a strong internal reaction in you, the artist, and kindles a desire to share your excitement. To open your mind to these moments, take a walk and tap into your creativity. Use your sketchbook. Try different angles with your camera. Give the artist inside something to absorb, distill and personalize.

After you choose your subject—something you feel strongly about—design a simple pattern. A pattern is the placement of shapes on the page. Your concept or theme may be about the light coming through a piece of glass, a

*Reference Sketch in
Watercolor*

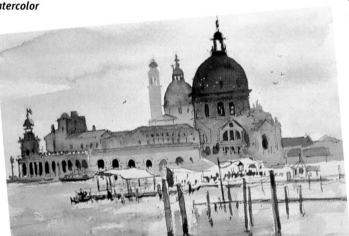

bank of fog nestling in a valley or an experiment using all the nuances of the color red. As you become more proficient at the pouring process, ideas will come in abundance. Much truth is contained in the saying "A painting begets a painting."

SKETCHING AND PHOTOGRAPHY

My paintings are a combination of on-site sketches and reference photos, which provide some details. As artists, it's our job to go beyond what the camera reports. Let go of the superfluous. Use only what helps you tell your feelings about what you paint. Simplicity of design, color and means will provide the unity necessary for a successful painting.

Sketches provide inspiration later in the studio. These quick impressions trigger memories of the weather, color, smells and sounds of the subject. How we feel about the place becomes more important than the details of its structure. Even the smallest study sharpens our observations and makes us acutely aware of our surroundings.

By planning a simple design and saving the white paper with a masking material, you're free to pour with power and a lack of fear. Enjoy the process and the product will take care of itself.

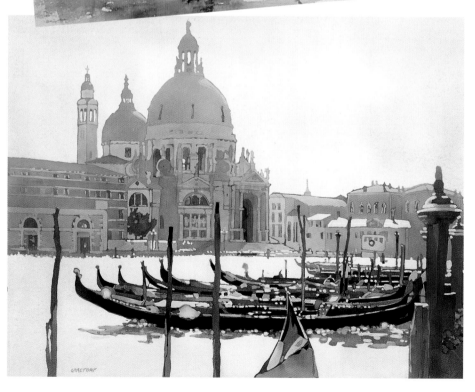

The Final Result
While planning the larger studio painting, I decided to use the color yellow to give a consistent warmth to the sky and water. The gondolas were important to the scene, so I made them larger and simplified the network of pilings. The gondola in the foreground breaks up the horizontals and also provides the viewer with an entry into the painting. My photos helped when it came to the details of the architecture and the gondolas, but the sketch is what put me back in this most picturesque of cities.

LAGOON
22" × 28" (56CM × 71CM)
COLLECTION OF JANIE AND DAVID VAUGHAN

The camera is widely used to gather painting material, but remember that the purpose of painting is not to duplicate the photo. The photograph shows everything and gives it equal emphasis. An artist is free to take only what he wishes to include, making shapes bigger or smaller, lighter or darker, warmer or cooler. Each of these decisions pushes the painting toward a more interesting composition that reflects the painter's personality. Be selective, focus on what is important, and save the extraneous for another painting. What drew you to that particular subject? Concentrate on that, rearranging and simplifying to emphasize that attraction. The elegance of a well-planned painting is the result of things left out rather than added in.

Reference Photo

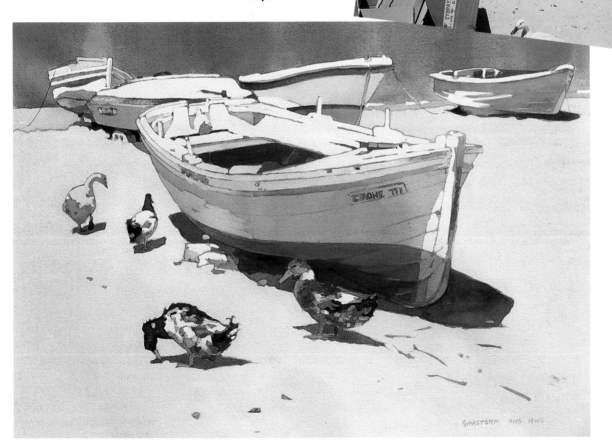

Focus on Boat and Ducks

The beach photo is full of activity. It includes many distant boats, hills, houses, people, boxes, etc. After all these extra elements were deleted, I could concentrate on what was of particular interest to me—the beach, boat and ducks. Focusing on only what was necessary to tell this particular story helped me avoid confusion—for myself and the viewer.

BEACH ON MYKONOS
20" × 28" (51CM × 71CM)

COLORS

AS YOU CHOOSE FROM THE WIDE RANGE OF AVAILABLE COLORS, KEEP ONE THOUGHT IN MIND: THE FEWER THE BETTER.

A limited palette will create unity in your painting and will help you understand color interactions. Once you absorb these lessons, you'll be free to concentrate on what you want to say.

The three primary colors are called that for a good reason. They are the basis for the complete spectrum of colors. With these three colors—red, yellow and blue—we are rich. Despite being limited to three colors, we will still have the full range of hue, value and saturation.

PAINTS

Da Vinci Phthalo Blue, Red Rose Deep and Hansa Yellow Light, three primary pigments, work well for pouring because of their transparency. The American Journey brand offers similar hues but gives them different names: Joe's Blue, Rambling Rose and Sour Lemon. Because of the size of the tubes, they are all conducive to squeezing out a generous amount of paint. This is necessary to produce the beautifully flowing, juicy blends that make watercolor sing. It is too easy to

> ### ■ HOW TO DESCRIBE ■ A COLOR
>
> **Hue.** The name of the color. That is, whether it is red, yellow or blue, purple, green or orange.
>
> **Value.** The lightness or darkness of a color. Pink is a lighter value of red. Yellow is a naturally light value, while red is a middle value, and blue is a dark value.
>
> **Saturation.** The brightness or dullness of a color. Another way to describe saturation is intensity. As color is squeezed from the tube, it is at its full saturation.

be fainthearted when you use tiny, expensive tubes. Pan colors aren't usable for pouring. Save them for your outdoor sketches.

You can also use other pigments for pouring. For instance, Winsor & Newton Winsor Red, Winsor Yellow and Winsor Blue will blend to produce wonderful oranges and browns. Occasionally, I will even use secondary or intermediary pigments in a pour. Experiment with other colors to find which types suit you best.

For direct painting, I find myself enjoying the more heavy-bodied pigments such as Holbein Cerulean Blue and Cadmium Red Light. DaVinci Burnt Sienna glazes beautifully over the primary colors and produces warm flesh tones. Holbein Cobalt Blue is a clean, true blue that is not as strong or dark as Phthalo Blue.

The paints from any of these companies will produce beautiful washes in a variety of hues, values and saturation. While I've only mentioned a few, there are many other fine paint companies with quality products.

The Primary Pigments
The primary pigments I use in pouring are red (Red Rose Deep), yellow (Hansa Yellow Light) and blue (Phthalo Blue). This handsome threesome by the Da Vinci Paint Company blend to form a variety of hues.

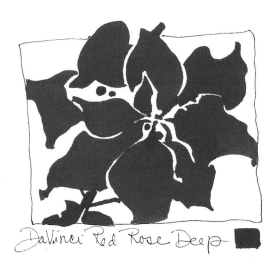

DaVinci Red Rose Deep

How Would You Describe This Swatch of Color?
What is its hue? What is the value? Has it become lighter with the addition of water? Is it bright color or has it become less intense from adding the other two primary colors? Try to duplicate it, keeping in mind that watercolors dry somewhat lighter. Watercolorists have an old saying: If it looks right when it's wet, it's wrong.

PAPER

EVEN IF YOU'RE NEW TO WATERCOLOR, DON'T DENY YOURSELF A
GOOD RAG SURFACE (PAPER AT LEAST PARTLY MADE FROM CLOTH).

If you practice pours and washes on an inferior paper, you'll fight an uphill battle. You'll have to learn it all over again when you switch to better-quality paper.

Arches 140-lb. (300gsm) cold-pressed paper will be used most frequently in the painting demonstrations. This paper accepts paint easily, takes the abuse of multiple maskings and pours, and dries fairly quickly.

SIZES

Paper comes in single sheets, rolls, boards and blocks. The most common size is a sheet that is 22" × 30"(56cm × 76cm). Watercolor boards, which have watercolor paper mounted on a sturdy, lightweight backing, can be used for pouring, but multiple washes may seep between the paper and backing board. I recommend using paper sold in the 22" × 30" (56cm × 76cm) sheet. For smaller work, it can be torn into half and quarter sheets.

Photo of Watermark
Locate the watermark by holding the paper up to the light. If the watermark is legible, such as "Arches," that is the right side. As soon as I identify the right side, I make a pencil mark on the paper's edge. This makes it easier to tell which side to work on.

WEIGHT

A paper's weight is determined by the ream (500 sheets). For instance, Arches 140-lb. (300gsm) is called that because 500 sheets measuring 22" × 30" (56cm × 76cm) will weigh 140 pounds (300gsm). The heavier Arches 300-lb. (640gsm) weighs over twice that. The 140-lb. (300gsm) is ideal for pouring.

SURFACES

A good analogy for describing paper surfaces is ironing fabric. If you press the material with a hot iron, the result is smooth and flat. This is "hot press," which is good for detailed work. A cooler iron (not hot) will produce a textured "cold press." The "rough" surface is the result of less pressing after the sheet of paper is formed. It has the most texture.

SIZING

Watercolor paper would act like a blotter if it didn't have "sizing." Sizing is a material such as rosin, glue or gelatin that's added as the sheet is being formed (internal sizing) or after it has been formed (external sizing) to strengthen the paper. This stronger paper makes a "harder surface," which allows you to wash out and make more changes. If a surface is too soft, it may tear and paint strokes will blur. For masking and pouring, you need a well-sized paper.

PERMANENCE

Another primary concern is the permanence of the paper used for watercolor painting. If it's properly stored or displayed, a good-quality acid-free paper will withstand the test of time without deterioration and yellowing.

 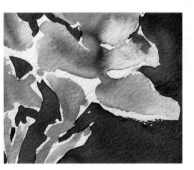

The Surfaces
The paper on the left is hot press. On this surface, paint forms puddles that dry with interesting edges—lots of fun mingling! Color is easy to lift from this surface. It's a great surface for detail.

The paper in the middle is cold press, our workhorse. Like hot press, it takes paint easily, but the color will sink into the paper. Washes aren't quite as easy to lift from this surface. This surface can withstand the abuse of repeated masking, pouring and lifting.

Rough paper (on the right) is good for rough-brushed edges and lots of texture. Because of the hills and valleys, the paint settles into washes with lots of sparkle. The liquid masks are a bit more difficult to apply and lift because of this unevenness.

Stretching Your Paper

Stretching watercolor paper has always been a part of my painting routine. Now that I pour pigments, stretching the paper has become even more important. If the paper buckles or moves during the pouring process, the washes are hard to control. Unwanted blossoms, streaks and muddy washes can result.

All papers used for pouring should be stretched and stapled, with a few exceptions: If the paper is small—11" × 14" (28cm × 36cm)—I will staple it down without wetting it first. A 300-lb. (640gsm) paper up to 15" × 22" (38cm × 56cm) doesn't need to be stretched, just stapled.

Taking the time to prepare the paper for pouring won't guarantee you a successful painting, but *not* stretching it will certainly make the job more difficult.

MATERIALS

140-lb (300gsm) cold-pressed paper with the right side identified

Gator board

Stapler and staples

Sink or tub to wet the paper

Masking tape

1 WET THE PAPER

By holding the paper under the faucet, gently but thoroughly wet both sides of the paper so it is shiny with no dry spots. To drain the excess water, hold the paper vertically until the water stops dripping.

2 PLACE THE WET PAPER ON THE GATOR BOARD

After checking that the right side of the paper is facing up, hold the paper by two diagonal corners. Place it on the Gator board so the edges of the paper and board are even. Let the paper fall naturally. If you see any humps or bumps, lift and let fall again. Avoid pulling or stretching.

3 STAPLE DOWN

Place a staple in the center of each side. Turn the board and place a couple of staples next to the ones you just put in. Work from the centers to the corners as you keep turning the board. Staples should be parallel to the paper edge and about 1" (25mm) apart. The corners are the most likely areas to curl up, so place staples there. If you see bumps after the paper is stapled down, don't worry; it's still expanding and will flatten out as it dries. Lay the paper flat to dry. After it's dry, cover the staples with masking tape. This prevents washes from running into the staple holes and creating blossoms.

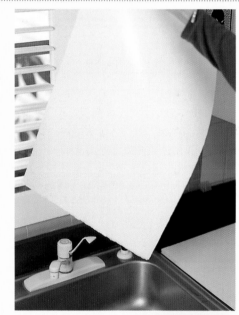

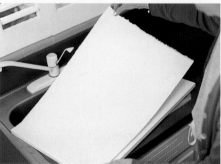

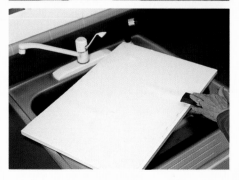

■ WORKING WITH ■ PAPER

When it is wet, paper is fragile. The surface is easily damaged by fingernails, pencils and staplers. Check that your hands are oil-free, because this can damage the paper, too. These slight abrasions may show up later when paint is applied.

Do not remove the paper from the board until you've completed the painting. The stapling creates a smooth, stable painting surface that you can pour on many times without excess buckling.

Avoid removing too much sizing from the paper. I used to soak my paper in a tub for a half an hour but found that the paper became too absorbent, like a blotter. The masking and pouring process also removes sizing, so let's leave some in there to work for us.

BRUSHES

WHILE I OWN DOZENS OF BRUSHES, I ALWAYS REACH FOR A FEW FAVORITES.
Some instructors have said the kolinsky sables are absolutely necessary, but I have not found that true for me. The essential thing is that the brush makes the stroke I want. It should function as an extension of my hand, making marks that reflect my intentions and feelings.

BRUSHES AND THEIR USES

To wet the paper and to paint large shapes, you'll need a 2-inch (51cm) flat. It should be made of soft hair, either natural or synthetic. While I sometimes use a 2-inch (51cm) flat made of squirrel, it took a while for it to stop losing hairs. Practice strokes with your large flat and you will find it gives excellent control. It will make details when used upright and hold enough water or pigment for big washes.

The 1-inch (25cm) flat is a workhorse. It can be used for washes or to form various shapes such as trees or houses. Dragged on its side as a drybrush stroke, it adds texture and detail.

Round brushes are numbered to denote their sizes. The smaller the number, the smaller the brush. I find the no. 8 is a good versatile size. When it holds a sharp point, it produces fine, controlled details. For calligraphic marks and your signature, purchase a small script liner or no. 2 rigger. If you have the opportunity to test these brushes before purchasing, do it. Swirl the brush in a glass of water to see if it holds a point. If the fibers separate, reject it and try another.

To mix your paints and water in their containers for pouring, any small, soft brushes will work. I choose ones with different color handles in order to avoid mix-ups.

Catalogs of art supplies offer a lot of information on brushes. Use them to learn about all the sizes, shapes and fibers available. Again, keep it simple. Take the time to become acquainted with each of the few brushes you really need. You will then be able to tell by feel how much moisture it holds and if it is ready to deliver the desired mark. Keep your brushes moving and practice your strokes. A brush mark made with confidence will add to the beauty of your watercolor. A strong statement boldly made, even if imperfect, is preferable to a weak, pale painting.

The Basic Brushes
What works well for me are Cheap Joe's Golden Fleece brushes; they have a good snap, keep a point, hold a good amount of paint and are inexpensive. From left to right the brushes are a no. 2 rigger, no. 8 round, 1-inch (25mm) flat, and a 2-inch (51mm) flat.

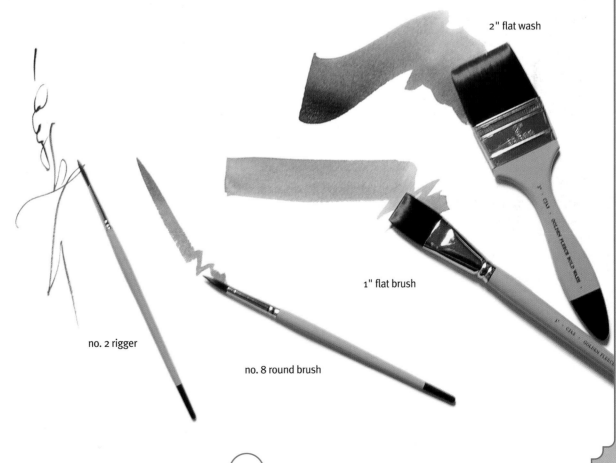

2" flat wash

1" flat brush

no. 2 rigger

no. 8 round brush

OTHER MATERIALS

POURING HAS SOME UNIQUE REQUIREMENTS.

You may have already discovered a few, like Gator board (or a similar board that will take staples) to stretch your paper, but you'll also need containers to mix the paints and a tub to catch the poured-off pigments. You'll need masking materials such as tapes, liquids, papers and wax crayons, but we'll cover those later in more detail. Can you create successful watercolors with just paint, water, brushes and paper? Yes, but it is great fun to find and experiment with new materials and methods along the way.

▦ GENERAL MATERIALS ▦

SUPPORT
Arches 140-lb. (300gsm) cold-pressed paper

Gator board (or similar)

Masking tape

Sink or tub to wet the paper for stretching

Stapler and staples

POURING MATERIALS
Brushes, small round with multiple colored handles, to mix paints

Clear plastic cups to mix paints

Pipettes

Soft sponge

Spray bottle

Tissues or paper towels

Tub to catch runoff paint

Water container

MASKING MATERIALS
Masking brush (such as Tak-lon brush)

Masking fluid and film can

Masking tape, watercolor tape, painters' tape

Razor blade

Rubber cement pickup

Soap, liquid or bar

Water

BRUSHES
2-inch (51mm) flat

1-inch (25mm) flat

No. 6 round

No. 8 round

Script liner or no. 2 rigger

Your favorite rounds for direct painting

MISCELLANEOUS
Craft knife

Graphite paper

Kneaded eraser

Light box

Long straightedge

Markers, gray and black

Palette or paper plate for direct painting

Pencils, no. 2 and 6B

Ruler

Sketchbooks

Tracing paper

Experiment With Different Materials
I experimented with watercolor tape (also called washout tape) and a craft knife in this painting. I covered the whole surface with strips of tape. I then cut interesting shapes from the taped surface with the craft knife. I painted the surface, cut more shapes, then painted the surface again. The white shapes were left covered with tape throughout the process. Since there's no drawing, the procedure (which I call "spontaneous painting") is one of observation and reaction, but not planning. A challenging way to work!

FOREST STREAM
14" × 20" (36CM × 51CM)

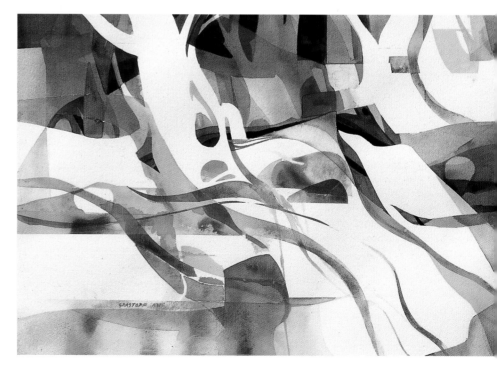

STUDIO SETUP

AS AN ARTIST YOU SHOULD HAVE A PLACE OF YOUR OWN TO PAINT AND STORE YOUR SUPPLIES.

One of my suggestions for a good working environment is that you find an area where you don't need to be concerned about protecting the floor or furniture. A creative mind may sometimes lead to painterly spills and spatters. Before I started to pour my paints, I had a carpeted floor. Now, it's tile. The alternatives are to use drop cloths or to move outdoors when you pour.

Part of being an artist is to grant to yourself the space and materials necessary to advance your skills and increase your productivity. While many wonderful watercolors have been painted on kitchen tables, having better conditions will make the process a lot more enjoyable and increase your rate of success.

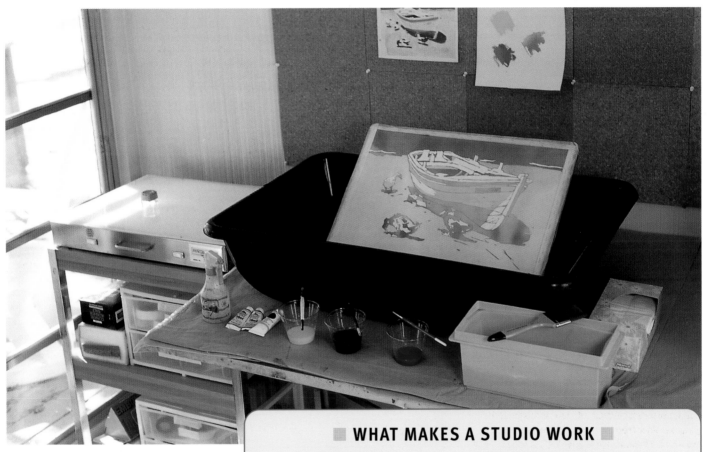

My Painting Space
The painting, drawing table, pouring tub, water and paints are ready at hand. On the taboret to the left, there's a light box. The light box is a recent addition and has been used to not only examine slides but to plan compositions and trace drawings onto the watercolor paper.

▦ WHAT MAKES A STUDIO WORK ▦

Good lighting. This may be natural or color-corrected lights. Since I prefer daylight, large windows are an important part of my space.

Source of water. If the kitchen, laundry or bathroom is close by, you can easily find clean water. Keep paint and used water out of the kitchen.

Adequate space. This means room for a flat working surface, such as a drawing table. My table, which is 36" × 48" (91 cm × 122cm), is always in place. Works in progress can remain in view, ready for a quick fix or longer contemplation. If you have to set up your painting space each time, chances are you will not paint as often.

Storage. I am fortunate to have found an architect's flat file that has many large narrow drawers for papers, sketch pads, tracing paper and mats. Fine art papers need to be protected from humidity, heat, dust and sunlight. My taboret on wheels is often pulled alongside the drawing table. It stores brushes, water containers and paints.

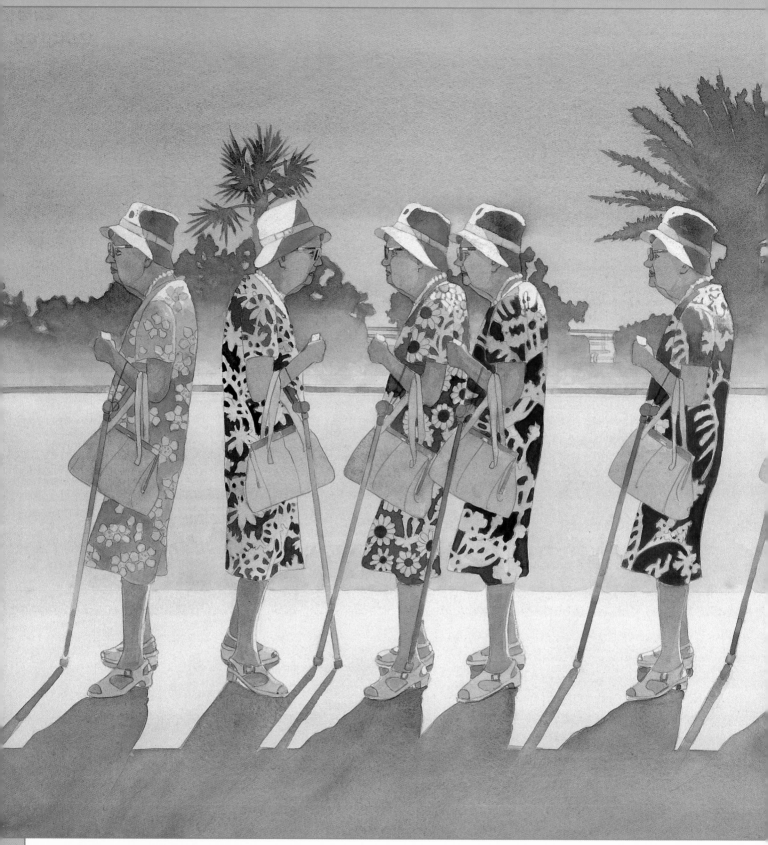

TRANSFER AT WILLIAMS PARK
20" × 28" (51CM × 71CM)
PERMANENT COLLECTION OF THE NEVILLE
PUBLIC MUSEUM OF BROWN COUNTY,
GREEN BAY, WISCONSIN

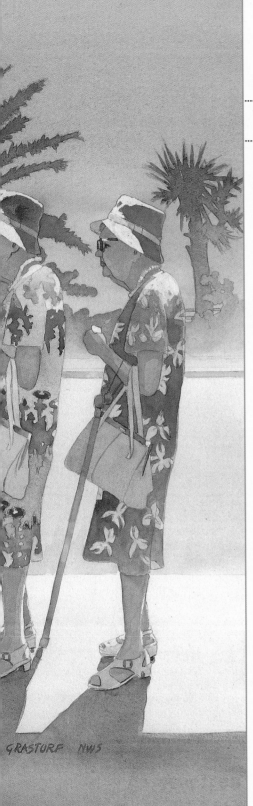

GRASTURF NWS

2 DESIGN: KEY TO SUCCESS

Each artist solves the problems of designing differently. There is no right or wrong way—only a series of decisions that, once made, lead to the next step. Good drawing skills come with practice. Color theory and watercolor techniques may be conquered with study. If, however, the artist has not planned his concept with a sound underpinning, the painting will fall apart.

Composing a painting means arranging shapes in a given space. The elements and principles of design are useful guides; they are not rules to restrict our creativity. As a teacher and juror of exhibitions, I've viewed hundreds of watercolors. Most are competently painted, but many fall short in the presentation of a simple, cohesive visual statement. We all have unique experiences; now, we must plan a way to share them in a soundly conceived and composed fashion. Just as a song needs a melody to hold it together, a picture depends on an underlying structure—a deliberate placement of forms in an orderly manner. In this chapter, we'll examine some "rules of the road" as we map out our journey toward a fresher and more imaginative organization of the pieces of our visual puzzle.

THE ELEMENTS AND PRINCIPLES OF DESIGN

IN ORDER TO ACHIEVE YOUR VISUAL GOAL, YOU'LL NEED SOME ESSENTIAL TOOLS. These tools are the elements of design, and the goals are the principles of design. For example, contrast is a principle (goal) that you can achieve with a cool element (tool) in a warm painting. Just as a cook creates a cake from flour and sugar, an artist uses line, shape and color to create unity, harmony, rhythm and balance. Baking a cake might be a bit easier, but not nearly as satisfying.

THE ELEMENTS OF DESIGN

Shape Paintings are made up of shapes, which become symbols. Most objects can be identified by shape whatever their size, color or value. A chicken shape will always be the symbol for a chicken even if it is blue or pink. The quality and creativity of the shapes and their interdependence will determine the success of the painting.

Line A closed line may be used as a contour to border a shape, and a segmented line as a compositional element to enhance or decorate.

Direction Every shape and line will have a direction. The options for direction are the stately vertical, the tranquil horizontal and the ever-exciting diagonal. Having direction will create movement into, around and out of the picture.

Value The lightness or darkness of a color is its value. A black-and-white photograph uses the different values of gray in portraying an image. Each shape will be assigned a value in order to take its place in the pattern of our design.

Texture Spattering paint, repeating dry-brush strokes, stamping with a sponge or flinging alcohol—all produce a simulation of texture. A pattern of repetitive texture can produce movement or direction, while one small textural element in a plain field becomes a painting's focal point.

Color The design element that speaks to us most intimately is color. Color depends totally on its neighbors for effect. A dull color in one setting can become vibrant elsewhere. To change one color in a composition is to change them all. Purple will be warm on a blue background, but appear cool on a red one.

Size When we think of size we think of large versus small, with large being the dominant shape. This is useful in design planning. If you start with one or two large shapes to anchor your design, the smaller pieces fall into place more easily. Size, like color, is relative. If a large shape fills too much space, it becomes the background rather than the dominant shape.

THE PRINCIPLES OF DESIGN

Unity At the top of the list in creating a successful painting, unity will keep all the necessary parts of a painting cohesive. The parts will consist of contrasts and variations while still maintaining a harmonious whole.

Contrast Here is an opportunity to charge your painting with a dash of pizzazz. The contrast might be that bit of bright color in a subtle, monochromatic landscape or a few small shapes among monolithic forms. These flashes of contrast should be done with restraint and a reason.

Repetition Repetition and contrast need to coexist in painting. Like sweet and sour, one is simultaneously enhanced and controlled by the other. Think of a fence with an unchanging repetition of the pickets. Now imagine the fun of pickets that vary in size, direction, color, shape or value. Repetition is unifying. Contrast prevents boredom.

Gradation The gradual, quiet transition of a design element, such as color, will move the eye from one area to another. Often the landscape foreground is too much the same color and needs more variety. A wash that goes from a dull color at the border to a brighter hue toward the center will bring attention there. Gradation of color and value naturally occur in a beautiful way in the pouring process.

Harmony Don't confuse harmony with unity. Harmony is a means of achieving unity. If your theme is circular, using this geometric shape throughout will create harmony. Or you could

▦ THE COMPONENTS OF A COMPOSITION ▦

Use this as a checklist to help avoid pitfalls and clichés in your compositions.

ELEMENTS	PRINCIPLES
Shape	Unity
Line	Contrast
Direction	Repetition
Value	Gradation
Texture	Harmony
Color	Rhythm
Size	Balance
	Dominance

choose colors that are close in hue and value to present a feeling of peace and tranquillity.

Rhythm A much overlooked principle of design, rhythm may help infuse the trite and predictable with a spot of salsa. Does your painting of a busy boatyard feel too quiet for the theme? To liven it up, add an irregular beat. Space them with a syncopated rhythm: Instead of DockBoatDockBoatDockBoat, try DockDockBoatDockBoat. This can be a lot of fun, but don't get too carried away by the music.

Balance Most of us have an instinctive sense of visual balance. An artist may opt for a symmetrical balance, in which each half is identical to its opposite side. This is frequently found in formal portraits or religious pieces, but it can be stiff. Asymmetry can balance a painting, but unequally. For example, a small detailed shape may balance a large but plain area. Opposites achieve a neutral balance in the mind of the viewer.

Dominance Since dominance is the factor that rallies all the diverse parts mentioned above, I left it for last. All other elements are subordinate to the dominant element. Dominance doesn't cancel out these inferior elements; instead, it emphasizes one clear thought or theme. All other elements are interpreted in their relationship to this theme. The dominant element will be the first strong impression when viewing the work.

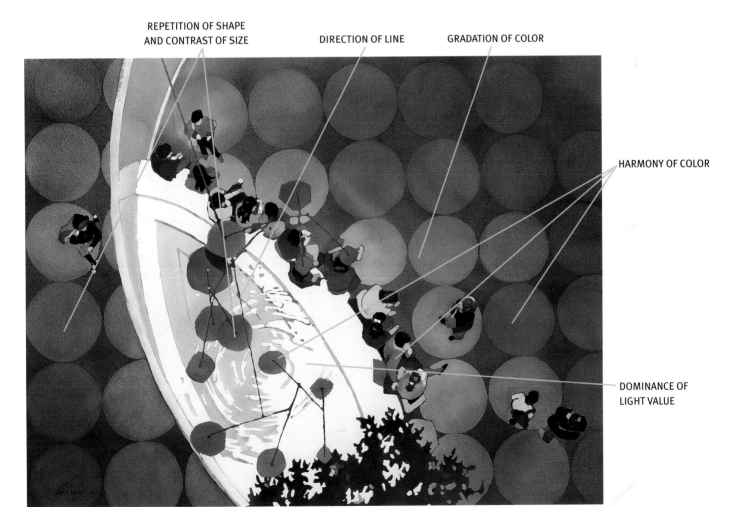

REPETITION OF SHAPE AND CONTRAST OF SIZE

DIRECTION OF LINE

GRADATION OF COLOR

HARMONY OF COLOR

DOMINANCE OF LIGHT VALUE

The Elements and Principles of Design at Work
These wonderful tools help you compose in your own unique way. Painting is problem solving; you'll find answers with the help of these "tools, not rules." Can you find other examples of the principles and elements at work in this painting?

GUGGENHEIM
20" × 28" (51CM × 71CM)

PLACING SHAPES IN THE FORMAT

THE FORMAT YOU CHOOSE SHOULD FIT THE THEME.

A vertical format would give you the opportunity to show the imposing height and strength of a lighthouse standing alone. A sweeping view of midwestern hills and valleys would be reinforced by a long, horizontal format. Just because you have a frame of a certain size doesn't mean you need to paint to fill it. Choosing the size and orientation of the image is central to the creative process and should be planned as carefully as the shapes that will fill it.

CONNECTIONS AND RELATIONSHIPS

As you plan the parts in your design, be aware of their relationship to the whole page. A simplified design will help keep the main, large theme visible. Connecting shapes through hue, value, proximity or size will help to unify the diverse elements.

WHAT MAKES A GOOD SHAPE?

A good shape really is in the eye of the beholder, but the definition most often given is: four sides of different lengths, a diagonal movement and interlocking edges. This will often eliminate the basic shapes of squares, circles and triangles when they appear alone.

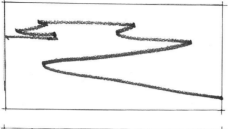

Determine the Lines
The four lines of the border define the format and proportions of the design. The fifth line represents the action line and entry into the painting.

Establish the Shapes
Within the format, the lines for the large shapes are planned. Lines indicate the movements into and around the format. The lines intersect the borders, making the borders become the shape edges.

Add the Values
The lines become shapes and are given light, dark and middle values. Now we are thinking like painters.

A Good Shape
This is a good shape. It has some interlocking edges that reach two sides of the format.

A Better Shape
This is a better shape. The shape extends to more of the borders. It also has a diagonal thrust and more interlocking edges.

ESTABLISHING A FOCAL POINT

GETTING THE VIEWER'S ATTENTION IS CERTAINLY A WORTHWHILE GOAL.

Most of us want to avoid the apathy that sends our audience on to the next painting. A strong, simple pattern with a clear focal point will catch the eye and hold the interest. The theme or concept should be readily discernible.

Using the elements and principles of design is a great way to emphasize the center of interest. The most common method is contrast. By making something different from the surroundings, it stands out. Another method is placement; an object isolated from similar forms is a visual point of interest. This is also true for the center of radial lines as in plant and floral forms.

Keep in mind that while the focal point should stand out, it must still remain part of the whole and relate to the other parts. If it is too strong or too different, it creates ambiguity. The viewer will just feel like it doesn't belong there. To make your intended message clear, you need unity.

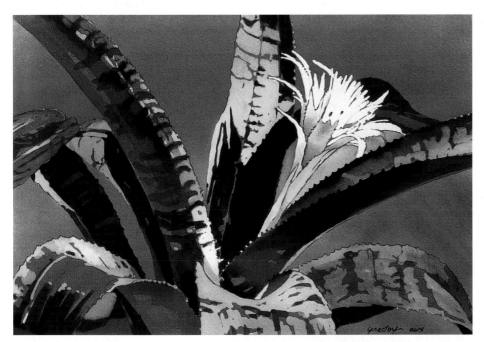

Contrast Emphasizes the Center of Interest
The focus is on the white blossom because of the contrast of values. The movement is diagonal from lower left to upper right and is indicative of a plant's growth as it seeks the light.

BROMELIAD
15" × 20" (38CM × 51CM)
COLLECTION OF DAN AND SHELLY FEEMAN

An Overall Pattern
Several contemporary artists such as Andy Warhol and Jasper Johns have ignored the common use of a focal point for a pattern of overall repetitive forms. Sometimes no area is emphasized, while in other paintings subtle changes create a path for the eye to follow throughout.

SOME BASIC DESIGN STRUCTURES

THROUGH THE CENTURIES, ARTISTS HAVE PLANNED COMPOSITIONS AIDED BY A SIMPLE UNDERLYING STRUCTURE. Before you put brush and paint to paper, decide which of several basic designs would most effectively convey your theme.

A horizontal format of fields and low hills will appear placid, while tall, vertical forms may suggest growth in a majestic forest. When the design fits the concept, you are already well on your way to achieving your goal. Keeping this "skeleton" simple will clarify your thinking and keep you on track. I think of a painting as a journey. When you plan the trip, a map heads you in the right direction. As you travel along, several possible side trips will appear for you to explore. These different roads can still lead you to your destination. The big plan will always be there to keep you headed toward your goal.

A Curving S-Shape
A path into the picture was planned to lead the eye to the center of interest, the beached boat.

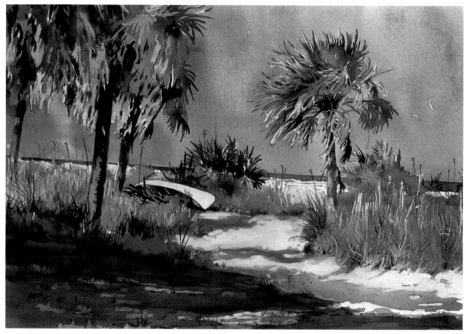

BEACH
15" × 20" (38CM × 51CM)
COLLECTION OF MARGARET CORNISH AND
EDMUND DEBARBA

A Circular Design
This painting has the feel of circular movement found in nature's patterns. Look for circular shapes in ripples in water, seashells, tree trunks, fruit and vegetables.

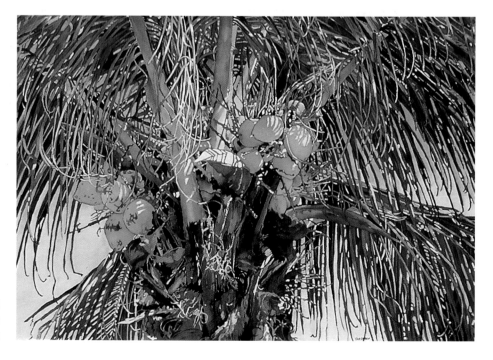

FRILLY PALM
28" × 38" (71CM × 91CM)
COLLECTION OF BEATRICE ROBERTS

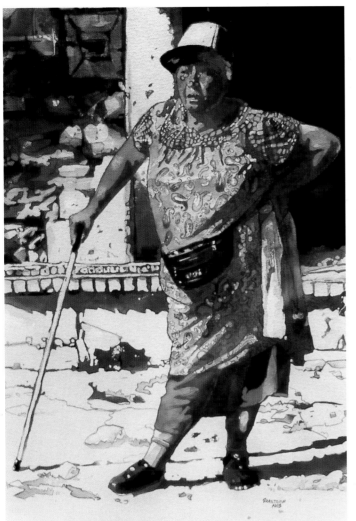

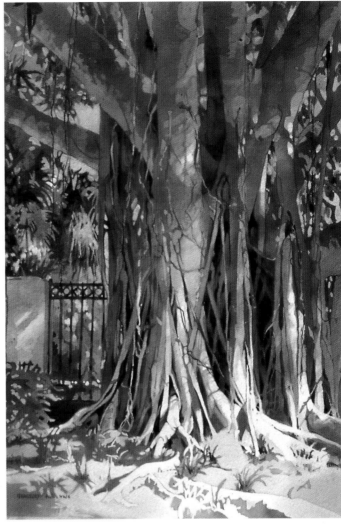

A Cross or Cruciform Design

The cross or cruciform is a way to attach the subject to the borders of the painting. When you use this format, make sure the four corners vary in shape and size.

CHICHEN ITZA
28" × 20"
(71CM × 51CM)
COLLECTION OF
LEROY SPRINGS & CO., INC.

A Vertical Structure

A vertical subject in a vertical format reinforces the theme of growth and strength. The simple but effective format is hard to ignore.

BANYAN
28" × 20" (71CM × 51CM)

CHOOSING A POINT OF VIEW

AMONG THE DECISIONS TO BE MADE BEFORE YOU PAINT
IS THE ONE REGARDING THE POINT OF VIEW.

Among the decisions to make before you paint is the decision regarding point of view. Do you favor a scenic panorama encompassing the vast landscape? How about a close focus featuring details revealed in the façade of a mansion? You might consider looking down for a bird's-eye view or up to capture the great height of a magnificent building. Choose whatever point of view will best reinforce your concept and entertain the viewer. Don't settle for the obvious.

As you gather information with your sketchbook and camera, investigate new ways to present your concept. Learn to see and interpret what you see in a more personal, creative way.

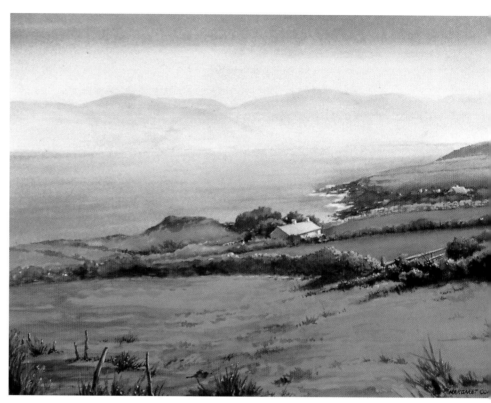

A Welcoming Format
This serene landscape reveals the beauty and charm of a panoramic format. Such a broad view invites us to enter and enjoy our visit.

THE SOLACE OF IRELAND
BY MARGARET CORNISH
20" × 28" (51CM × 71CM)

A Close-Up
A close-up of the historic Curry House draws our attention to the carved details. This view also highlights the colorful cast shadows and their diagonal movement.

KEY WEST HOUSE
28" × 36" (71CM × 91CM)
PRIVATE COLLECTION

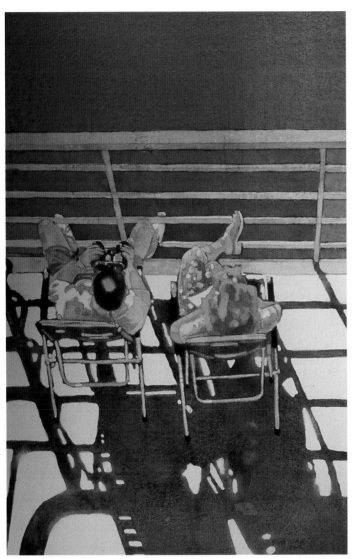

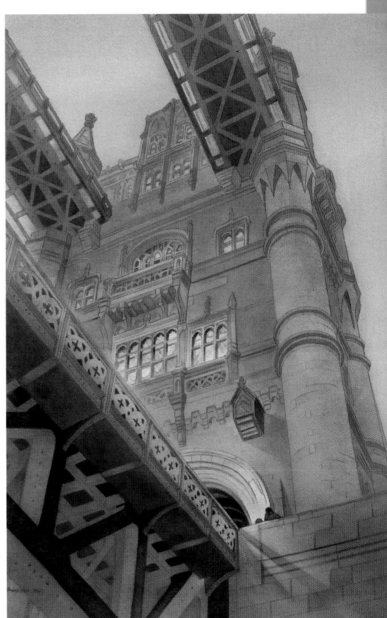

The Extreme View, From Above

Looking down offers an opportunity to explore how shapes and their shadows reveal themselves in new and exciting ways.

SHIPBOARD SHADOWS
20" × 14" (51CM × 36CM)
PRIVATE COLLECTION

The Extreme View, From Below

Gazing up at a tall structure increases our awe of its size. It fills the page with a massive presence. The scale of the bridge is emphasized by the small figure.

TOWER BRIDGE
35" × 24" (84CM × 61CM)
COLLECTION OF RICHARD J. AND
SHIRLÉ L. NANULA

THE IMPORTANCE OF LIGHT

TRANSPARENT WATERCOLOR REVEALS THE PLAY OF LIGHT
MORE FULLY THAN ANY OTHER MEDIUM.

Because of the transparency of the washes, light can go through the layers of paint, hit the underlying white paper and bounce back to the eye. To use watercolor to its full potential, choose subjects that have light through, on or around them. When I'm outdoors with my camera, I want the sun to be shining. If it is a cloudy day, I sketch or work in the studio. This is my preference, but you may be attracted to misty rain or foggy days. Whatever you decide to paint, light in some form will play a major role.

THE SUN FROM DAWN TO DUSK

As the sun's rays move throughout the day, the character of the light changes. In the early morning, when the sun is low on the horizon, the light is seen through more of the atmosphere. This produces a warm, rosy glow with cool shadows. The sun at high noon is white and bleaches out color on the surfaces it hits. The cast shadows are dark, and the variety of colors in them are hard to see because they're such a contrast to the light areas. Noon is a time of strong value contrast. As the sun progresses toward late afternoon, warm hues steadily return with lengthening shadows.

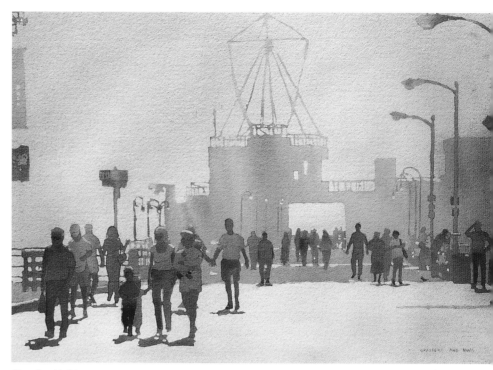

Morning Light
The morning light comes through the fog turning people into silhouettes and bathing them in a warm, glowing atmosphere.

DETAIL FROM:
SANTA MONICA PIER
20" × 28" (51CM × 71CM)
PRIVATE COLLECTION

High Noon on Palm Fronds
At high noon the overhead sun removes color from the fronds. Where the light shines through the fronds the beautiful colors remain. The colors that we see at midday are little influenced by the atmosphere. Grass looks green and your blue car looks blue. Little color distortion occurs, especially on sunny days.

PALM FRONDS
20" × 28" (51CM × 71CM)
PRIVATE COLLECTION

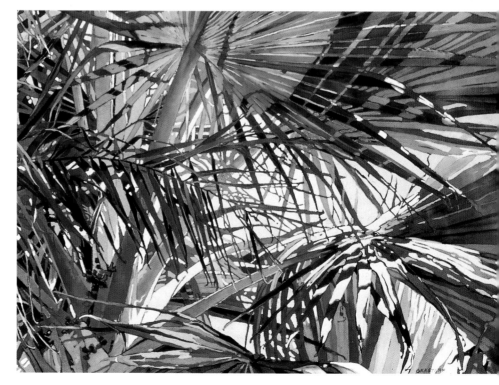

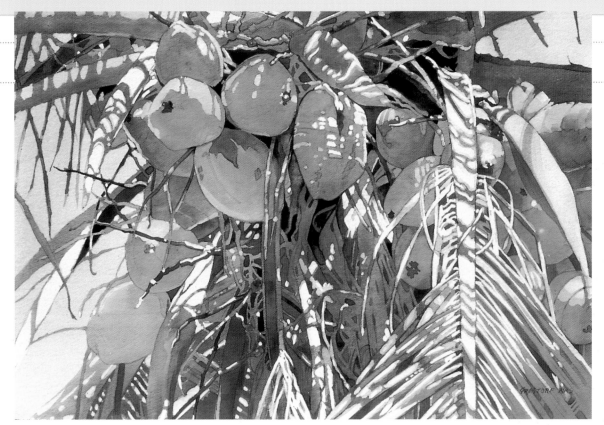

Sun and Shade
Here the sun is still high, but it's beginning to drop. It produces a dappled effect as its light travels through the fronds. Since the light is more diffused, the shadows are full of color and detail. I spent a great deal of time planning the effects of sun and shade.

SUN-KISSED
20" × 28"
(51CM × 71CM)
PRIVATE COLLECTION

Twilight becomes a time of mystery. Colors soften, shadows become muted and objects have a look of golden warmth. I like to think of the atmosphere as filled with particles of dust and water vapor. These veils of air form tiny rainbows. As objects move away from us, they become paler, bluer, less detailed and smaller with softer edges. When capturing the fleeting effects of light with the camera we need to compensate for its shortcomings. Dark values appear darker and less colorful with harder edges, especially in shadows. Also the perspective of buildings is distorted and will need to be adjusted in the painting.

While I am attracted to objects because of the glorious quality of light, I never forget the importance of shapes as they are formed by the light and shadow. That all-important simple, abstract pattern remains the basis for a successful painting.

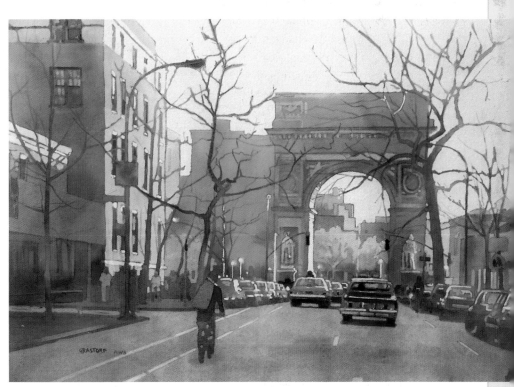

The Light of Dusk
The end of the day bathes the scene in a rosy glow as the sun is filtered through layers of tiny particles in the atmosphere. To help me tell this story, I used repeated washes of poured watercolor in yellows, reds and pale blues.

SOUTH ON FIFTH 1
20" × 28 (51CM × 71CM)
PRIVATE COLLECTION

3 COLOR:
TRANSPARENT VEILS

Color is the element of design that reaches beyond the intellect to the heart. While color may seem intuitive, studying it will free you to paint even more creatively. Nature presents us with a palette of many local colors, but a painting that tries to reproduce these local colors exactly will lack unity. As artists we notice and appreciate the wonderful colors that fill our world, yet limit ourselves to a few and still produce a beautiful painting. Once you know what color can do, it becomes a powerful element.

The organization of color is all-important to the painting process. When you pour colors, watching the pigments flow and blend may seem like pure fun. Well, it is, but like all things in life, it must be balanced with some degree of control. A good working knowledge of the paints and their interactions prevents confusion and disappointment.

Pouring color will prove to be unpredictably creative. Soon, you'll find yourself abandoning green trees and blue skies. Since we recognize an object by its shape, not its hue, you can use color to affect, charm and entertain the viewer.

GRASTORF AWS

SPRING BOUQUET
20" × 28" (51CM × 71CM)
COLLECTION OF SUSANNE RUSSELL

CREATIVE COLOR

WHEN AN ARTIST ALLOWS PIGMENTS TO FLOW, THE RESULTS MAY OBEY CHANCE RATHER THAN THE ARTIST'S INTENTIONS.

This can be a bit disconcerting at first. However, through masking to preserve the whites, mixing paints to control values and using gravity to direct movement, harmony and unity will prevail. At the same time the unpredictability of pouring will favor creative color. Skies may turn yellow, seas orange and trees purple. Shapes will still remain familiar and identifiable while the mood and emotion of the painting prevail. Letting go of preconceived ideas of what something should look like is a difficult but necessary step toward more creative and personal color. Pouring colors on wet paper will lead to results you could not totally anticipate. Cameras replicate reality with more predictable results. As artists working with paint, we aim to depict a different reality. We need to interpret and communicate our feelings to the viewer and elicit a response. And creative color is one of the most powerful tools for that purpose.

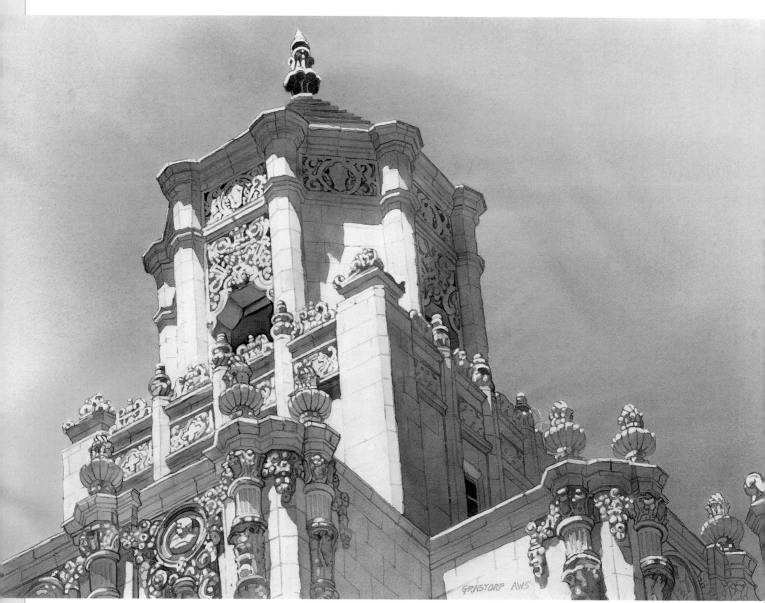

Reinterpreting Blue Skies
Yellows, yellow-greens, greens and blue-greens flow throughout. While these colors may take little from the actual scene they satisfy the desire to create a totally unique reality. Skies may be any color, but the usual blue would have detracted from the warm dominance that holds the painting together.

SNELL ARCADE
20" × 28" (51CM × 71CM)

THE COLOR WHEEL

WHEN LIGHT PASSES THROUGH A PRISM, IT BREAKS INTO A
SPECTRUM OF INDIVIDUAL COLORS: RED, ORANGE, YELLOW,
GREEN, BLUE, VIOLET AND THEN BACK TO RED.

Sir Isaac Newton was the first to organize this spectrum into a circle. Later studies in color—by both scientists and artists—have resulted in other variations of the color wheel. These are all simply different ways of organizing color. Traditionally, artists' color wheels illustrate the relationship between the primary, secondary and intermediate hues.

PRIMARY COLORS

Those who work with photography have a different set of primaries than those artists dealing with paint, but for our purposes, the primary colors are red, yellow and blue. The basic color wheel is composed of just the primary colors. Theoretically, these three colors—with the addition of black and white—will produce all the other colors.

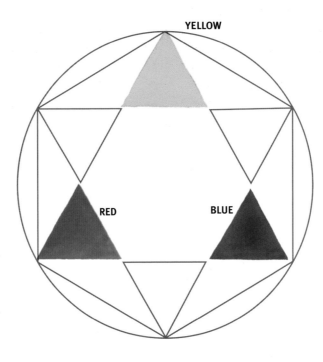

YELLOW

RED BLUE

The Primary Colors
This simple triad of the primary colors using Da Vinci Hansa Yellow Light, Red Rose Deep and Phthalo Blue are the same hues used in many of the paintings in this book. They may not necessarily be the purest forms of the primary colors, but these particular pigments have other attributes. They're staining colors: Instead of sitting on the paper's surface, they actually become part of the paper by staining it. The other quality common to the pigments in this triad is their level of transparency. All three are highly transparent, allowing the light to pass through to the paper's white surface and bounce back to the eye. Even after multiple glazes or pours, the transparency of these colors remains.

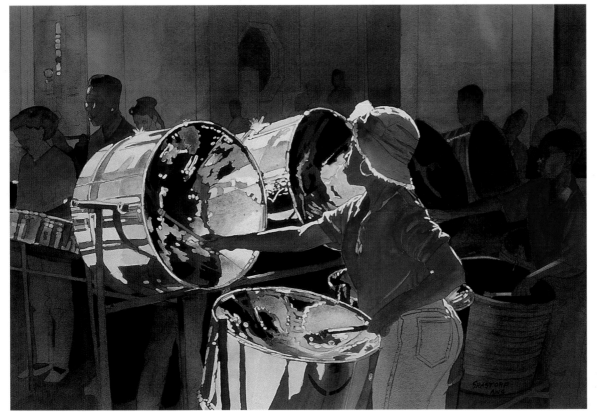

Primary Colors Working Together
The drummer, the drums and the background all rely on the primary colors. The Red Rose Deep and Phthalo Blue produce deep, rich darks without losing their transparency. The reflections called for strong contrasts and hard edges, with the white paper playing a major role. With the Hansa Yellow Light, the value range is extensive—from the darkest darks to lightest lights.

STEEL DRUMS
20" × 28"
(51CM × 71CM)
COLLECTION OF
CINDY
JEDNASZEWSKI

SECONDARY COLORS

Combine any two primary colors and you'll get a secondary color. For instance, adding red to yellow will make orange. You can create quite a variety of oranges with only these two colors. If the red is strong and the yellow is diluted, you'll create an orange that's totally different from one that's mostly yellow with a dash of diluted red. Try mixing a variety of purples from red and blue. Try it for blue and yellow, too, to make green, but keep in mind that blue can easily overpower yellow. Blue will have to be diluted to allow yellow to show its beauty in the secondary color of green.

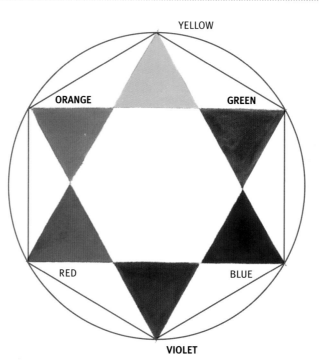

The Secondary Colors
You can see in the color wheel the three primaries and three secondaries. The secondary colors are mixed from the primaries. Red and blue make violet; red and yellow make orange; and blue and yellow make green. These six colors will have many possible variations depending on the strength of their components.

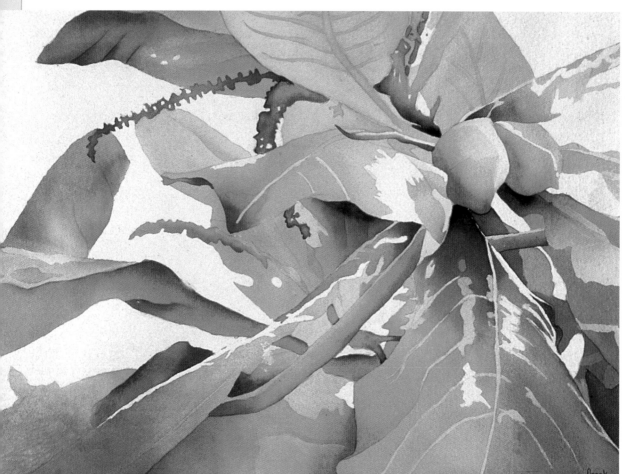

Secondary Colors in Gradation
In the beautiful gradation of warm to cool leaves, the secondary colors of green and orange appear prominently. The blending of the primaries on the wet paper led to clean and luminous secondaries. The wonderfully designed shape of the plant leaves provided a great variety of negative spaces.

GOING BANANAS
BY KAAREN ORECK
14 ½" × 19 ½" (37CM × 50CM)
PRIVATE COLLECTION

INTERMEDIATE COLORS

My favorite combinations are the intermediate colors. These lovely hues are created when a primary, such as red, is added to a neighboring secondary color, like orange. This new color is an intermediate color referred to as red-orange. Red could also be combined with its neighbor violet to make red-violet. Any primary combined with the nearby secondary will produce one of those lovely intermediate colors. (Notice that the primary color is always mentioned first in these mixtures.)

TRIADS

A triad is a group of three colors that are equally distant from one another on the color wheel. The three primary colors form a triad. Another triad would be orange, violet and green, the secondary colors. For a more subdued triad, use Yellow Ochre for primary yellow, Burnt Sienna for primary red and Cerulean Blue for primary blue. The only requirement is that the colors appear at equally distant positions on the color wheel.

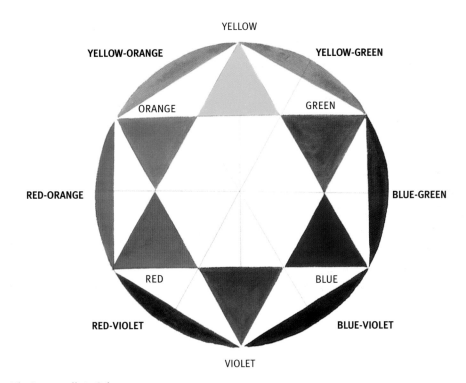

The Intermediate Colors
The intermediate colors (sometimes called tertiary colors) are those beautiful hues made by mixing a primary color with a secondary color. For instance, mixing the primary blue with the secondary green will make blue-green, and adding primary yellow to the secondary green creates yellow-green. Mixing primary blue with secondary violet makes blue-violet, but mixing primary red with the secondary violet will produce the intermediate red-violet. When naming the intermediates, the primary color—red, yellow or blue—is always mentioned first.

The three primary colors and three secondary colors combine to make six intermediate colors. The color wheel is now complete with twelve hues, all mixed from Hansa Yellow Light, Red Rose Deep and Phthalo Blue.

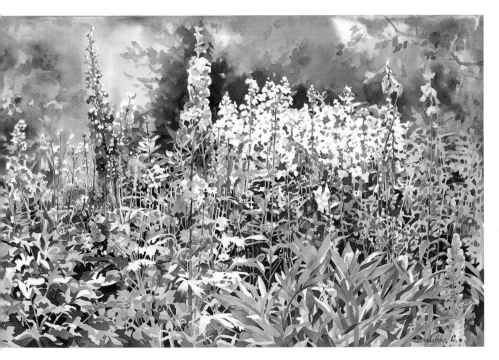

An Array of Intermediate Colors
The intermediate colors abound in this overall pattern of blooms. Can you find some yellow-greens and yellow-oranges, blue-greens and blue-violets, red-oranges and red-violets?

SONDRA'S GARDEN
28" × 36" (71CM × 91CM)
PRIVATE COLLECTION

ADJUSTING COLOR: VALUE

THE COLORS ON THE COLOR WHEEL ARE AT THEIR MOST INTENSE RIGHT OUT OF
THE TUBE, AND YOU'LL WANT TO ALTER THEM TO SUIT YOUR PAINTING. IN ORDER
TO HIGHLIGHT SOME SHAPES AND SUBDUE OTHERS, IT'S NECESSARY TO
CHANGE SOMETHING, USUALLY VALUE AND SATURATION.

VALUE

Adjusting color to further the theme or concept of your painting
can be done in several ways. One of the easiest and most com-
mon ways is to adjust a color's value by either lightening or
darkening it. Value is important since the eye focuses first on
the contrast between light and dark. Watch for opportunities to
use both strong darks and lights within a painting.

Every pigment has an inherent value. Of the pouring pig-
ments, Hansa Yellow Light is the lightest value and is difficult
to darken. Red Rose Deep is a natural midtone, but it can be
darkened or lightened. Phthalo Blue, the darkest value, can
also be lightened.

A darkened version of a color is called a shade. Adding black
to a color certainly produces a darker value of these hues,
though they wouldn't be as transparent or colorful. The best
way to produce a darker value is to combine the primaries.

A lightened color is called a tint. To lighten a color's value in
watercolor, you generally add more water. You can use white
pigment, but the color becomes opaque. You can create some
lovely versions of peach, pink and ivory with white paint.

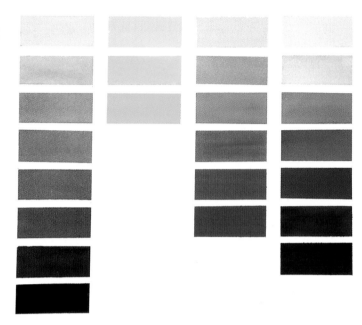

A Value Scale With the Primaries
In these value scales, you will notice that Da Vinci Phthalo Blue is a dark value.
It can be diluted with water to produce a variety of lighter values (tints). The Da
Vinci Red Rose Deep is a somewhat lighter value that can also be diluted to
make tints. Da Vinci Hansa Yellow Light starts out as the lightest value, so it
can be diluted into only a few more tints.

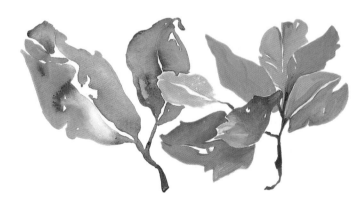

Shades of the Primary Red
When a color is darkened, it becomes a shade of that color. To make a shade,
you can add black. It can also become darker by using the primary colors. In
the color swatch to the left, Da Vinci Red Rose Deep has been combined with
M. Graham Ivory Black. Compare this with the other swatch mixed from the
three primaries, Red Rose Deep mixed with Hansa Yellow Light and Phthalo Blue.

While the Ivory Black is useful, I think blends made from primaries are
much livelier. When making dark value mixtures, try to do it quickly with little
manipulating; let the paint blend on its own.

Opaque and Transparent Tints
Colors can be lightened with water (as in the value scale above), or they can be
combined with opaque white pigments, like gouache or acrylic. The leaves on
the left are transparent pigments lightened with water. The leaves on the right
are painted with the same transparent pigments lightened with opaque white
gesso. The leaves on the left have a good variety of color and nice, juicy
blends. The leaves to the right have a flatter color. Tints created with opaque
media can be interesting and useful, but I prefer the transparency water pro-
vides.

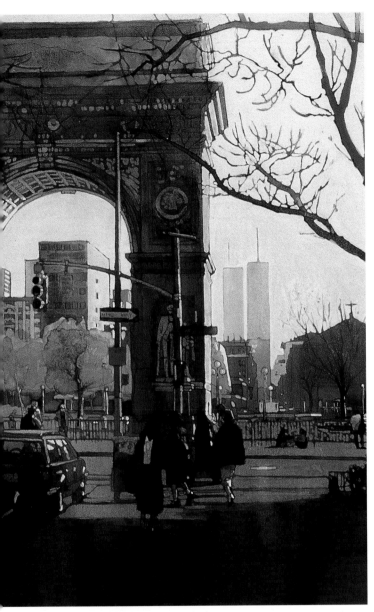

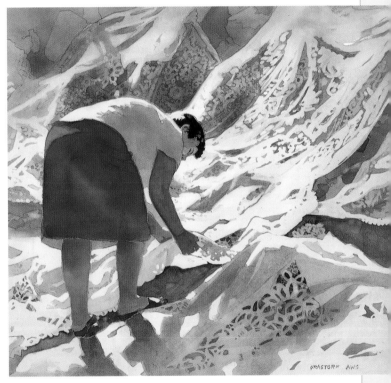

A Dramatic Low-Key Scene

Because of the many darker values, this painting could be called low-key. The use of the darker values is an effective way to show a quiet, rather somber scene. In a darker painting, it works well to add sparks of bright color to liven it up. Night scenes with a single strong light source would fall into the low-key category.

SOUTH ON FIFTH 2
28" × 20" (71CM × 51CM)
PRIVATE COLLECTION

A Challenging High-Key Scene

When a painting has an abundance of light values, it's called high-key. Sometimes a high-key painting will lack punch because it has no strong value contrast. It may be necessary to gain and keep the viewer's interest solely with the subject or with nuances of color.

LINDOS LACE
20" × 28" (51CM × 71CM)
PRIVATE COLLECTION

ADJUSTING COLOR: SATURATION

ONE WAY TO ADJUST A COLOR IS TO CHANGE ITS VALUE. ANOTHER IS TO CHANGE ITS SATURATION. *Saturation* refers to a pigment's purity. A completely unadulterated pigment is highly saturated.

SATURATION AND GRAYING A COLOR

A painting filled with many colors fighting for attention is similar to having too many tenors in the same opera: Something has to give. When all the colors of the spectrum appear together in full, intense saturation, they lose their identities. By strengthening one main color group and subduing the rest, harmony returns. Unity may be achieved or lost through color.

When we desaturate a hue, it becomes less full of color and may even be gray. Subtle grays made from several colors will settle into any color scheme without disturbing the balance and order. Generally, a desaturated color is referred to as a *tone*. A dull maroon, for instance, would be a tone of red. It's darker in value, like a shade, but also not as bright.

One way to desaturate or subdue a color is to add the *complementary* color. This is the color across from it on the color wheel. Since green sits across from red on the color wheel, green is red's complement. Orange is blue's complement, and violet is yellow's. An easy way to remember the complementary color is that it is a combination of the other two primaries.

Sometimes using the complement may change the temperature too much, and cools become too warm and warms too cool. If this should happen, such as in using violet to gray a yellow, try the secondary colors on each side of the yellow. Add green and orange to bring back the warmth.

Another way to desaturate or subdue a color is adding an *analogous* color. Analogous colors are generally any three neighboring colors on a full color wheel. The analogous colors can desaturate a primary without changing its temperature, which might happen when you use the complementary color.

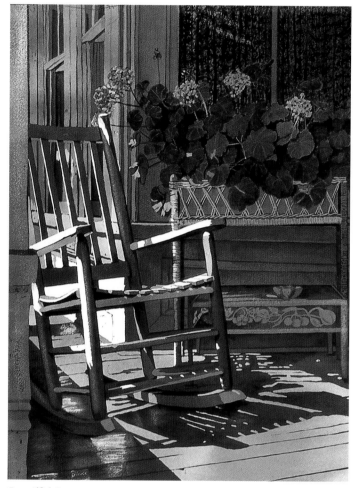

Beautiful Grays
The artist has created an arrangement of extraordinarily beautiful and harmonious grays. Because of the subtle nature of the subdued tones, the viewer enjoys the value contrast of the sunlight on the rocker and then discovers the delicate pink geraniums. The painting has a lovely dreamlike quality that reinforces the nostalgia of the subject.

NANA'S ROCKER
BY JUDY LAVOIE
29" × 21" (74CM × 53CM)

Graying the Primaries
Through the use of the complementary colors, the primaries become less vibrant. These subtle colors make wonderful tones. They will, by contrast, allow the bright jewels of full saturation to shine. Yellow is desaturated with its complement violet. Red is desaturated with its complement green. Primary blue is desaturated with its complement orange.

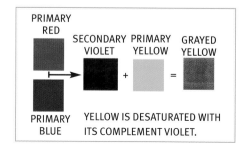

PRIMARY RED
SECONDARY VIOLET
PRIMARY YELLOW
GRAYED YELLOW
PRIMARY BLUE
YELLOW IS DESATURATED WITH ITS COMPLEMENT VIOLET.

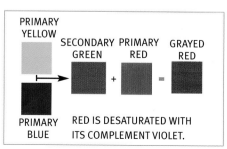

PRIMARY YELLOW
SECONDARY GREEN
PRIMARY RED
GRAYED RED
PRIMARY BLUE
RED IS DESATURATED WITH ITS COMPLEMENT VIOLET.

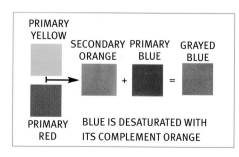

PRIMARY YELLOW
SECONDARY ORANGE
PRIMARY BLUE
GRAYED BLUE
PRIMARY RED
BLUE IS DESATURATED WITH ITS COMPLEMENT ORANGE

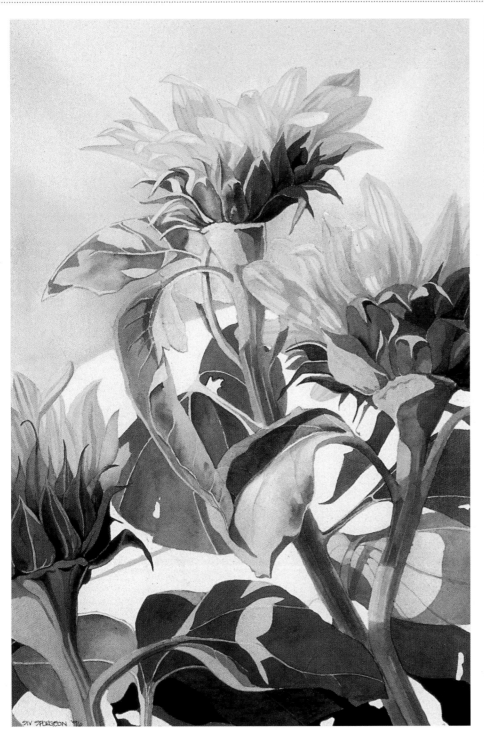

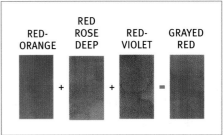

Desaturating Red
Red is desaturated with its analogous colors red-orange and red-violet.

RED-ORANGE	RED ROSE DEEP	RED-VIOLET	GRAYED RED

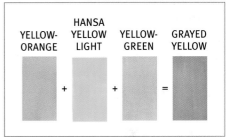

Desaturating Yellow
Yellow is desaturated with its analogous colors yellow-green and yellow-orange.

YELLOW-ORANGE	HANSA YELLOW LIGHT	YELLOW-GREEN	GRAYED YELLOW

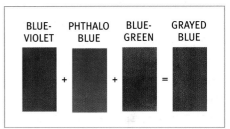

Desaturating Blue
Primary blue is desaturated by adding its analogous blue-violet and blue-green.

BLUE-VIOLET	PHTHALO BLUE	BLUE-GREEN	GRAYED BLUE

The Unity of Analogous Colors
By using the analogous colors, this experienced artist has retained the warmth of the yellow flowers. The yellows, yellow-oranges and yellow-greens are analogous colors. They appear next to each other on the color wheel.

Use of the complementary color of violet would have challenged the warm feeling of this sunny painting. Instead the unity of color perfectly suits the subject.

HELIANTHUS
BY SIV SPURGEON
20 ½" × 14" (52CM × 36CM)
COLLECTION OF THE ARTIST

PAIRING GRAYS WITH WHITE

**THE POWER OF THE WHITE PAPER IS PRESENT IN THESE TWO PAINTINGS THAT
LEAN HEAVILY ON DESATURATED COLORS.** Since little bright color is
present to catch the eye, the white is the star.

Don't overlook the beauty of desaturated colors. Their wonderful tones will harmonize and unify. Whether you desaturate with the complementary color or use the analogous hues, they'll make a stunning color scheme. A bit of thought and restraint in the planning will prevent disharmony and chaos in the finished painting.

White as a Central Player
The powerful white shapes of the man's cap and shirt suit the strong features of the sitter. Subtle colors and a variety of edge treatments distinguish this painting from the ordinary. The artist has emphasized the face with contrasts in value that help define the subject's personality. The shouts of bright reds, yellows and blues are unnecessary in such a well-planned arrangement of whites and grays.

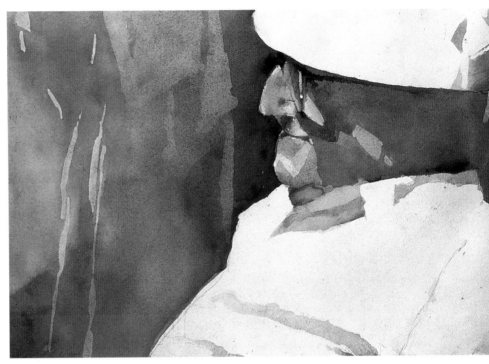

GEORGE
BY SUZY SCHULTZ
15" × 22" (38CM × 56CM)

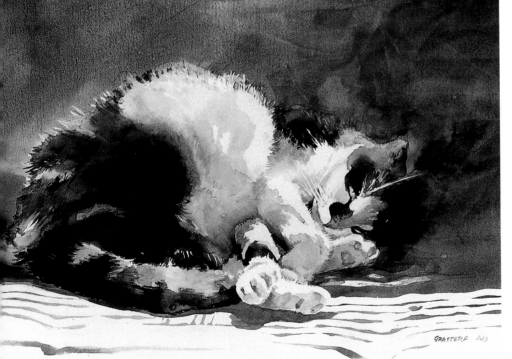

Using Edges
Here again the neutrals carry the day. The sole color that is almost full saturation is the bit of orange. We know that orange becomes brown when it is desaturated and darkened. The darks in this painting are a variety of warm browns and cool grays. Where the border of one shape meets another is called the edge. Edges appear soft when neighboring shapes are of a similar value. This is the case where the top of the calico's head blends into the background. Compare this kind of an edge with the eye-catching profile in Suzy Schultz's painting *George*.

CALICO
14" × 18" (36CM × 46CM)
COLLECTION OF JEAN AND ROB WILHELM

COLOR TEMPERATURE

KNOWING THE VOCABULARY OF COLOR HELPS US TO DESCRIBE AND DISCUSS THE POURING OF PIGMENTS AND THEIR RESULTING BLENDS.

When we talk about color, we know that *hue* is the name of the color, *value* is the lightness or darkness, and *saturation* the intensity or brightness.

To these descriptive terms, we need to add *temperature*. Whether a color is warm or cool is another property. So-called warm colors relate to the sun, fire and heat. They suggest excitement and energy. Reds, oranges and yellows create an active, stimulating palette. Cool colors are more calming and sedate. Blues, greens and violets would work for a soothing landscape. A color, however, is always judged in comparison to the hues that surround it. The neighboring colors will determine its temperature. For instance, violet will be the warmest color in a cool painting, but the coolest color in a warm painting. The relationship between colors is an important part of planning your painting.

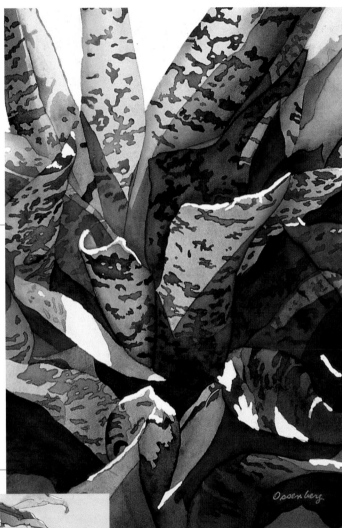

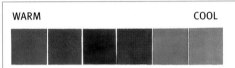

Violet as the Warm Touch
In this light-filled painting, the color violet appears warm in relation to the cool blues and greens. The hues might be limited, but the wide range of temperature and value provides plenty of variety. This is a fine example of using color to unify.

SUNSHINE MOSAIC
BY SUSAN OSSENBERG
15" × 11" (38CM × 28CM)
PRIVATE COLLECTION

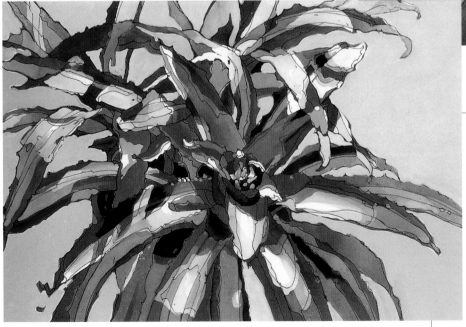

Violet as the Cool Accent
In a new, warmer environment, violet becomes the coolest color. The properties of a color are always determined by the colors around it. No color exists alone but finds its beauty with other, contrasting pigments.

BROMELIAD 2
14" × 20½" (36CM × 52CM)

PERSONALITY OF PIGMENT

PERHAPS YOU HAVE A SUBJECT THAT CALLS FOR A DIFFERENT TRIAD. THE TRIAD OF TRANSPARENT STAINING PIGMENTS WE'VE BEEN USING IS WELL BALANCED AND VERY USEFUL, BUT YOU MAY WANT MORE VARIETY.

For instance, if you want to create texture, you may select pigments that offer greater *granulation*. Granulation occurs when particles of pigment settle out from suspension into the hills and valleys of the paper. These grainy colors would work well for portraying ancient walls and buildings, sandy beaches and forest interiors.

Da Vinci Hansa Yellow Light, Red Rose Deep and Phthalo Blue work together for smooth graduation of color in transparent passages, but that may not always be your intention. Try out alternate triads with different qualities.

An Earthy, Granulating Triad
Raw Sienna (Da Vinci) is a warm, semitransparent yellow that granulates and lifts well. Burnt Sienna (Holbein) acts as the triad's red. It's warm, transparent and staining with some granulation. Cobalt Blue (Holbein) is a cool, transparent pigment that granulates some and lifts well. (It is also a potential health risk, so use cautiously.)

Notice that only the Burnt Sienna stains the paper. Since the others don't, you may accidentally lift too much pigment during the masking and pouring. It helps to mix these colors somewhat stronger at the beginning.

A Warming Triad
For a warming palette, replace Red Rose Deep with Winsor Red (Winsor & Newton). To warm this triad even more, substitute Hansa Yellow Medium (Daniel Smith) for the Hansa Yellow Light.

Hansa Yellow Medium is warmer than Hansa Yellow Light, transparent, and not very staining with little sediment. Winsor Red is warm, transparent, and staining with little sediment. It's strong and dominates most mixtures. Phthalo Blue (Da Vinci) is cool, transparent, and staining with no sediment.

Adding Hansa Yellow Medium to the strength of Winsor Red allows the warms to dominate over the powerful Phthalo Blue.

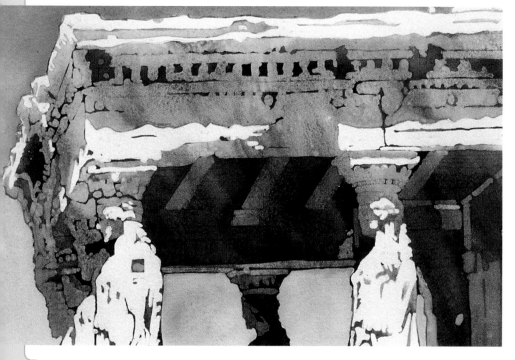

Grays With Character
The earthy triad mentioned above produced lots of granulation. While each pour was still damp, I used a spray bottle on the fine spray setting. This misting of water created an even more visible texture. The sky was masked from the other pours at the beginning. As a final step, it was unmasked and poured separately. The dominant color in this pour is Cobalt Blue, but the Raw Sienna and the Burnt Sienna give the sky its depth and variety. Since many of these pigments are nonstaining, I had to wet the paper rather gently between pours to avoid shifting the pigment. Can you see how wonderful this group of pigments would be for a stormy sky or the interior of a forest?

PARTHENON
14" × 18" (36CM × 46CM)
COLLECTION OF JANIE AND DAVID VAUGHAN

TRANSPARENT OR OPAQUE?

WHEN WE THINK OF WATERCOLOR, WE THINK OF TRANSPARENT WASHES.

Watercolor's ability to let light pass through to the white paper gives watercolor its many admirers. However, not all watercolor paints are created equally transparent. Some of them are downright opaque, allowing little light to pass through. This is fine as long as we know which way the various pigments will behave. The best way to confirm their individual quirks is to test them. To do this, paint a stripe of permanent black ink on a sheet of paper, let it dry and then run a stroke of a color over it. The opaques show up on top of the ink and the transparents allow the black to show through. Test your favorite pigments in

whatever brands you prefer. Some significant differences exist between brands, so this test is important.

Transparency is not necessarily right and opacity wrong. They're just different kinds of paint, but they complement each other in interesting ways. Adding gouache or gesso to watercolors will definitely add to their opacity. Since gesso dries waterproof, it will not lift, whereas the gouache will wash off. Using a combination of transparent and opaque pigments is well worth exploring.

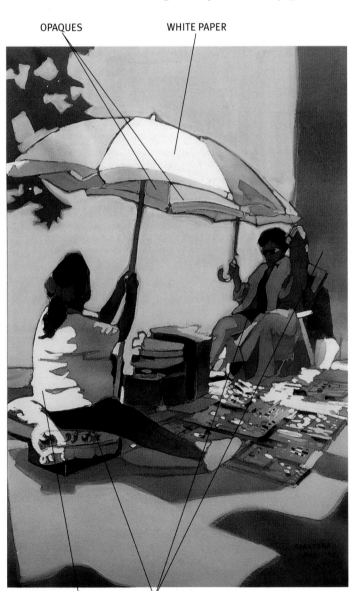

OPAQUES WHITE PAPER

WHITE PAPER TRANSPARENT DARKS

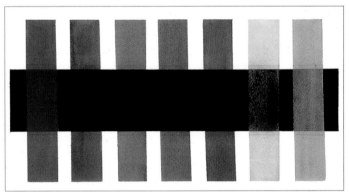

A Test Strip With Transparent and Opaque Pigments
This small sampling of pigments held some surprises. The Hansa Yellow Light seems to be less transparent on this test strip than I have experienced in pouring. This may be because it was brushed on quite thickly. Any color will be opaque if put down with little water. It sits on the surface rather than sinking into the paper. Notice how transparent the Red Rose Deep and Phthalo Blue are. Compare the opaque Cerulean Blue with the Cobalt Blue. Cobalt is a color that varies greatly between brands.

Working With Opacity
Opaque pigments appear throughout and contrast with the transparent washes. The dark shapes remain transparent and lively. While some white paper is still present, the large areas of the foreground and background are largely opaque. Art has room for many means of expression. Transparent, opaque, semitransparent, acrylics, gouache and granulating—all are exciting means of expressing yourself. Bite off small pieces in the study of the pigments to find out what they can do, then move on to another set of colors or mediums.

MARKET
20" × 14" (51CM × 36CM)

KEEPING IT IN THE FAMILY

AS YOU'VE LEARNED, THE ANALOGOUS COLORS ARE THOSE THAT ARE NEXT TO EACH OTHER ON A FULL COLOR WHEEL.

The analogous colors next to primary red are red-orange on one side and red-violet on the other. By extending the colors on each side to three, you have a primary color family with seven members. Look at the color wheel and find the three colors on the right side of primary yellow. They are yellow-green, green and blue-green; this is the cool side of yellow. On the left side of yellow are yellow-orange, orange and red-orange; this is the warm side of yellow. Every one of these yellow family hues has yellow in it—even blue-green because of the presence of green (a combination of blue and yellow).

Do the same exercise with the other primary colors. Using color families is another way to arrive at a compatible color scheme. It's like taking a slice out of the rainbow.

In planning your next painting, think about which of the primary color families would suit your subject. Even though this might limit the number of hues, you'll still have all their tints, tones and shades to lend variety and interest. Experimenting with color families is a good way to learn about the variations of color while maintaining a color harmony.

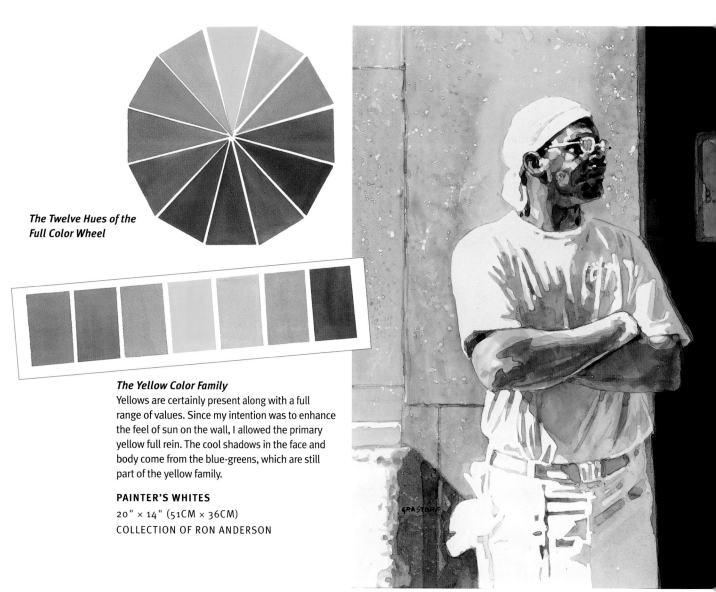

The Twelve Hues of the Full Color Wheel

The Yellow Color Family
Yellows are certainly present along with a full range of values. Since my intention was to enhance the feel of sun on the wall, I allowed the primary yellow full rein. The cool shadows in the face and body come from the blue-greens, which are still part of the yellow family.

PAINTER'S WHITES
20" × 14" (51CM × 36CM)
COLLECTION OF RON ANDERSON

The Red Color Family

There is absolutely no doubt that this is a red family painting! Red catches the eye and starts the heart racing. Here, the red is held in check by its fellow warm colors. If it had been in the presence of blues, the red would have had no chance to shine. In this family environment, it becomes a beautiful, strong color and an important design element.

NATURE'S BOUNTY
BY GAIL PETERS
19 ½" × 13 ½" (50CM × 34CM)

The Blue Color Family

The blue family definitely was part of the plan for this island scene. Red-violets, violets, blue-violets, blues, blue-greens, greens and yellow-greens are everywhere. The light hits the boat and reflects the blues inside and out. The blue family is a cool set of characters with a full value range and peaceful members.

BERMUDA BLUES
20" × 28" (51CM × 71CM)
PRIVATE COLLECTION

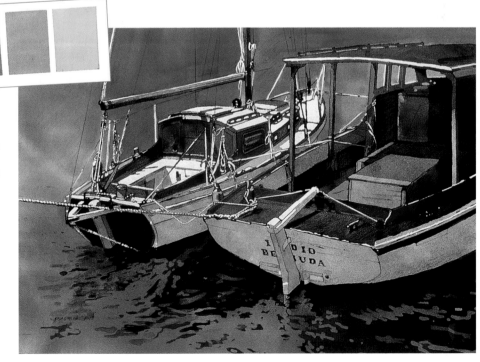

The Yellow Family at Work

In order to create a color family, one color has to dominate. This exercise will show you how this works. We'll use our "standard" triad of pouring colors—Da Vinci Hansa Yellow Light, Da Vinci Red Rose Deep and Da Vinci Phthalo Blue—to create the yellow family. As all the poured pigments blend, the yellow family will dominate. How? Because you'll have mixed that color strongest.

In this exercise, you'll be pouring and blending paints on wet paper (you won't be masking this time). The next chapter covers the pouring process in more detail, but we'll keep this demonstration simple enough for you to do now. Don't worry about creating a finished painting. This is an opportunity to see what flowing pigments will do.

MATERIALS

General Materials on page 18

POURING PIGMENTS
Da Vinci Hansa Yellow Light
Da Vinci Phthalo Blue
Da Vinci Red Rose Deep

Meet the Yellow Family
The yellow family includes yellow-orange, orange and red-orange, so you'll need the Red Rose Deep to make these colors. The cool side of the yellow family includes yellow-green, green and blue-green, for which you'll need Phthalo Blue.

1 MIX AND POUR YOUR COLORS

To begin, pick a simple design and draw it on the paper. Staple the paper to the board (it isn't necessary to stretch it) and put masking tape along the edges. Mix your colors—Hansa Yellow Light, Red Rose Deep and Phthalo Blue—in separate cups. Mix the yellow with the least amount of water to make sure that it will be the strongest. Wet the paper with a 2-inch (51mm) flat brush. Pour the colors so that the right side receives the cooler colors and the left side the warmer colors. Try to leave some areas as white paper. If you use the spray bottle, you can remove paint while it is wet and gain back the white paper. Tip the painting to let pigments pour off. Clean the excess paint from the tape. Let this dry.

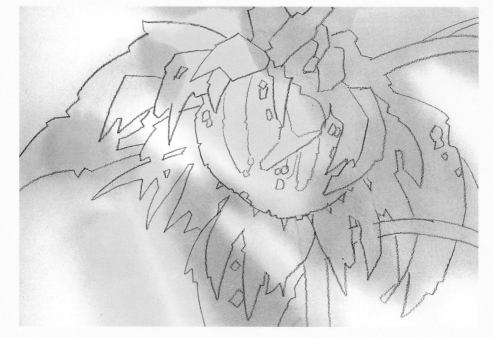

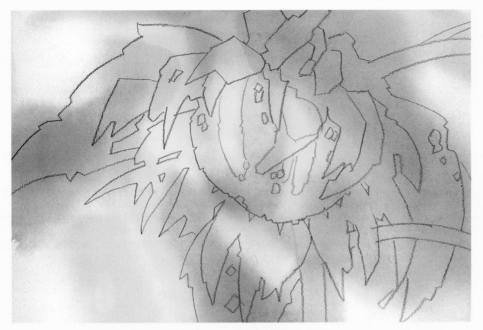

2 MIX STRONGER AND POUR AGAIN

Mix together fresh color in the cups. This time, add more pigment to the cups to make the colors a little stronger. Make sure the yellow is still the most dominant color. Wet the paper again and pour the paint so it blends as it flows. Tip the painting to pour off the excess, then clean the tape and let the painting dry.

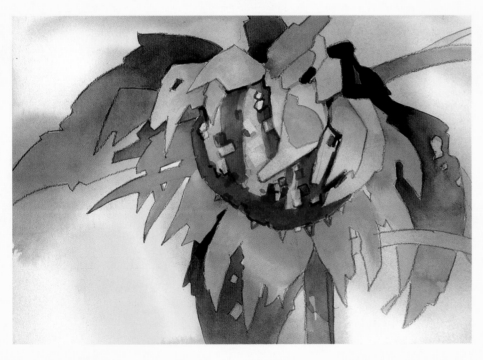

3 BRUSH ON THE DARKER DETAILS

The pigments used for pouring work for glazing, too, but the paint needs to be thicker. Use less water and mix these colors on a paper plate or palette. With the no. 8 round brush, add darker values wherever detail or more shape definition is needed. Remember that this is a simple study in "color family planning" and will introduce you to the wily ways of watercolor pours and blends. Don't be too hard on yourself if things get a little out of control; that's the excitement of watercolor. You may want to pick another color family to try this same process for a totally different result. If you like your drawing, use it again. You'll probably decide to simplify it.

COLOR CONTRASTS

CONTRAST CREATES EXCITEMENT. IT MAY BE USED TO PERK UP A TOO-NEUTRAL PAINTING OR TO DRAW ATTENTION TO AN AREA OF SPECIAL INTEREST.

The four properties of color—hue, value, saturation and temperature—all offer opportunities to explore contrast.

Look at some of your less-than-inspiring paintings. Could they do with a dash of contrast? Perhaps a stronger value contrast or a zip of warm in that cool landscape?

▦ COLOR REACTION ▦

Which of these paintings attracted your eye first? Which type of contrast do you find most powerful? In general, the eye is attracted to extreme value contrasts first. Was this true for you?

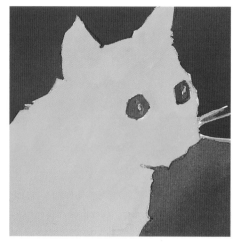

Contrast of Hue
These distinct, strong hues—both fully saturated—set up a vibration. The values are similar, as is the temperature, so the contrast is all about the two colors—yellow and red.

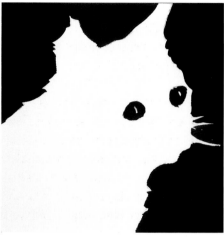

Contrast of Value
This painting shows extreme contrast. Though not quite the darkest dark, the purple is almost black; the white is certainly the lightest possible light. Most paintings have midtone areas to serve as a background. The midtones would be least likely to detract from the lively contrast of light and dark.

Contrast of Temperature
Both colors are light valued, fully saturated, but their temperatures are vastly different. In general, shapes that are warm advance and shapes that are cool retreat (which is a wonderful way to portray depth). Notice how the warm yellow practically pops off the page?

Contrast of Saturation
Bright, saturated color appears even more brilliant when compared to desaturated hues. Even in small amounts, intense color will light up a large expanse of subdued color.

COLOR INTERACTIONS

NO COLOR EXISTS ALONE. It is always compared to and influenced by the neighboring colors. Sometimes this interaction is caused by the chemical properties of the pigments. For instance, is it staining enough to conceal previous washes?

If it is nonstaining, will it survive the masking and pouring process? How will it combine with its fellow pigments? Will it granulate for texture? As painters, we need to know what paint will do.

Along with the physical aspects of the pigments, they also have the ability to arouse emotions. Since this is the subjective side of the study of color, we can't absolutely predict the response to any particular color combination. We can, however, make some general observations. Red is a compelling color; it implies strong feelings of ardor, valor and love, or conversely, cruelty and anger. Blue suggests peace, truth, loyalty and a calm atmosphere, but has an element of depression to it as well. Yellow signifies light, sun and, when matched with white, a "heavenly" glow, but it would be difficult to portray a strong emotion with just that light-valued twosome.

When these same colors are placed in different environ-

ments and different proportions, their impact changes. Many of these color connections are due to historical associations, though we also have a natural sensory response to color that plays a part in our reactions. The two are difficult to separate. The best we can do is rely on our own innate response to the color and relay it to our viewers.

Color schemes and plans aren't an exact science, especially when pouring. As you try different combinations, you'll find some special favorites. If you concentrate on the primary colors at first, you'll still be rich in color choices and combinations. You'll eventually find yourself reaching beyond these three to satisfy the needs of the painting and your curiosity. Color experimentation is one of the true joys of painting—even more so when it is based on an organized knowledge of the properties of color.

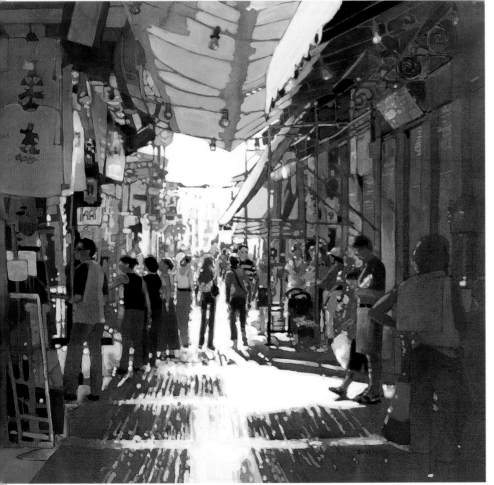

The Play of Color
Street scenes are full of activity. A hot afternoon in Athens with shoppers, awnings, signs and goods on display is no exception. The colors used are to further the impression of a busy market. The warm hues of red, orange, yellow and violet mirror this excitement. I let them dominate during the pours, then I reinforced them with sparks of pure color and strong value contrasts. The emotional impact of color made my job a lot easier. A cornucopia of colors in the spectrum is available to translate our deepest feelings. By studying their characteristics and learning how they interact we can then turn them loose and allow color to work its magic.

PLAKA 2
20" × 22" (51CM × 56CM)

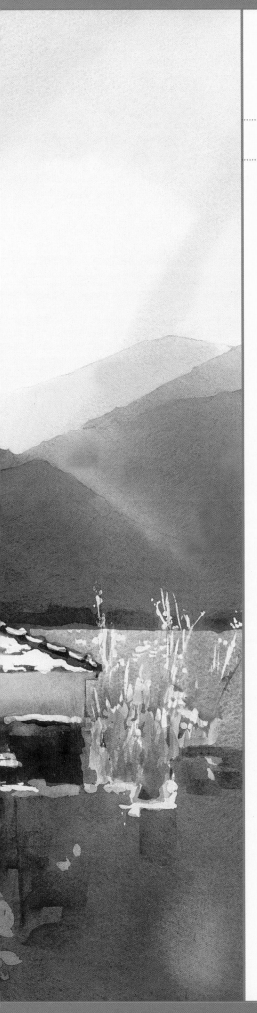

4 TECHNIQUE: MASK AND POUR

"Why do you pour?" is an often-asked question in my workshops. The best answer is that my work was not saying what I wanted to say in a way I wanted to say it. I had used watercolor glazes for many years, but to me they lacked luminosity and spontaneity. Through pouring, I found the clarity and freedom I was seeking. The paint did surprising things, better than I could have anticipated.

With the joy of pouring came the need to protect some areas from the wildly spreading paint. I tried out all kinds of masking tools. As problems surfaced, solutions were found. Obviously, I needed to plan and organize; I had to be a thoughtful painter concerned with shapes and values. I adapted, and all this adaptation led to continuous discoveries. I learned new techniques, but more importantly, I learned a new way of seeing and perceiving.

This chapter covers the entire process of pouring luminous washes, from the first glimpse of a possible subject to creating thumbnail sketches and value studies, enlarging an image and placing it on watercolor paper, masking, pouring, and adding the final brushstrokes. Much of this process may seem a bit unnecessary when you're anxious to paint, but be patient and do the planning. The reward—glazes of transparent color that cannot be created in any other way—is worth it.

SKOPELOS CHURCH
28" x 36" (71CM x 91CM)
COLLECTION OF ROB AND JEAN WILHELM

A REASON TO POUR

**THE DIFFERENCES BETWEEN DIRECT BRUSHWORK AND POURING
ARE GREATER THAN YOU MIGHT REALIZE.**

The manner in which the pigment meets the paper is quite different, of course, but so is the thinking prior to pouring. When you pour, you must consider the entire space within the borders. Many of us learned early on to paint the subject and then complete the background shapes. This may lead to a lack of concern for the "negative" shapes. As a general rule, you can say that the positive spaces in the painting are the subject of the piece and the negative spaces are the areas left over within the format. By masking and pouring a selection of shapes simultaneously—both positive and negative spaces—the painting is integrated with all the parts woven together.

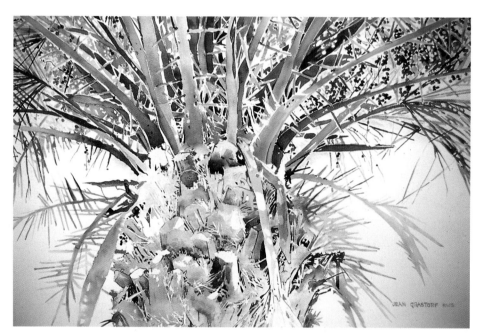

Direct Painting

This piece is an example of direct painting instead of pouring. The result is a high-key painting with little value contrast or strong color. Regarding the composition of the painting, the tree has been placed with not a lot of thought. The space around the subject should be as much a part of the design as the subject itself. One is there because of the other, and they are of equal importance. These negative areas need as much thoughtful attention as the positive shapes.

DATE PALM
18"× 24" (46CM × 61CM)
PRIVATE COLLECTION

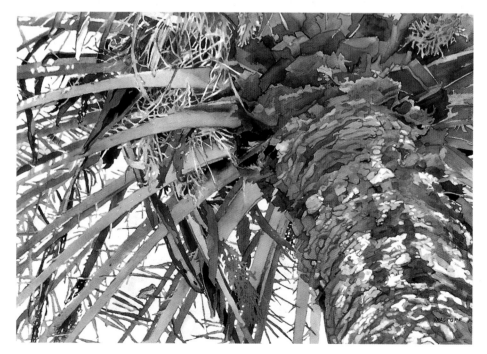

Pouring

A better design plan of subject and background results in more interesting sky shapes. With pouring, the fronds and trunk have a greater variety of color, but the most important improvement is in the composition. Pouring requires planning. Planning leads to better composition.

DATE PALM 2
20"× 28" (51CM × 71CM)
PRIVATE COLLECTION

SKETCH TO GATHER INFORMATION

DRAWING FROM LIFE STARTS THE CREATIVE JUICES FLOWING AND WARMS UP YOUR HAND-EYE COORDINATION.

A few lines in your sketchbook can instantly pull you back to the time and place in which you sketched the landscape, still life or model. You'll begin to remember not just what you saw, but what you heard, smelled and felt. Our powers of observation become more acute and we become more aware of both light and color.

Photos can provide additional information that may be helpful, but they aren't a substitute for that on-site sketch. If you're just starting out, it's important to put yourself in the world you are sketching rather than relying solely on photographs. The world exists in three dimensions; photographs exist in only two. Even if you took them yourself, you probably won't get that instant connection to the time and place that a sketch in your notebook can bring.

Another benefit to sketching on-site is the sense of depth you'll have and be able to bring to your painting. In planning our paintings, we usually consider the placement of shapes from top to bottom and right to left very well. The movement into and back out of the paper is often neglected. Don't forget the space that exists all around objects. A tree will have height and width and depth. Imagine putting your arms around it and give it room as you place it in the composition.

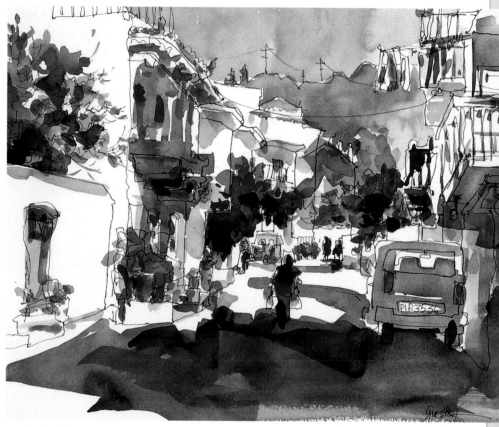

An On-site Sketch
I created this watercolor sketch of a Greek island street on-site. Since the light changes rapidly, I put down an ink line first, quickly following with an overall wash for the shadows. I completed the sketch with strokes of color and additional linear detail. This kind of sketch finds its value in capturing the light and feel of the moment rather than as a finished painting.

INK AND WATERCOL-OR SKETCH
12 ½" × 16"
(32CM × 41CM)

Isolating an Image With a Viewfinder
An interesting tool to simplify your subject is the Zoomfinder. This type of viewfinder has movable borders that can help you find a better composition by focusing in on a smaller area. Two formats are possible—a square or a rectangle similar to the proportion of a full or quarter sheet of paper.

When working from a photograph, cropping is essential. Place the Zoomfinder on the photo and move it around to discover a good, strong and simpler design. Another suggestion is to cut two L shapes from a mat. These can be moved around to any proportion. Finding a smaller and more creative composition hidden within a larger painting is a truly exciting discovery. It jolts our sense of design with an unexpected pattern of shapes.

THE THUMBNAIL

EXPLORING, SEARCHING, REACHING AND TRYING AGAIN ARE THE FIRST STEPS IN FINDING A WAY TO BEST EXPRESS YOUR CONCEPT.

The small designs called thumbnails or roughs are just that. Not much more than doodles, they suggest some ideas and eliminate others. The thumbnail can be any size that feels right to the artist. Mine are generally about 4" × 5" (10cm × 13cm). It's too small to be a big commitment of time or demand too much detail. Because risks are easy to take here—you have nothing to fear in such small attempts—an exciting and innovative composition may very well surface. Thumbnails help identify questionable designs and potential problems early on.

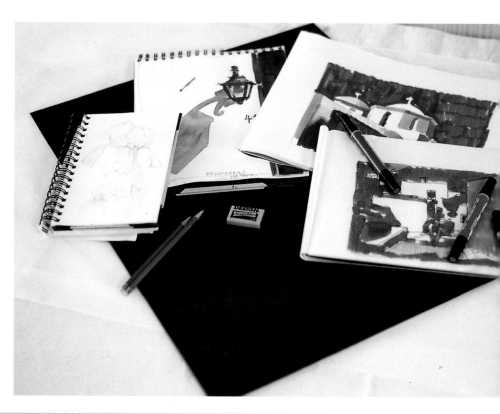

Materials for Thumbnails
Among the useful items are tracing paper in varied sizes, sketchbooks, pencils, markers in gray and black and a kneaded eraser.

■ WHAT TO TRY OUT IN A THUMBNAIL ■

Search for your motif. Is there a high or low horizon? Look for repetitions. Would circular or geometric lines best suit the theme? Is there movement into the piece?

- - -

Use a format that reinforces the subject—perhaps horizontal for a seascape, vertical for a portrait, square for a floral. If you feel adventurous, explore a vertical seascape, a square landscape or a horizontal floral.

- - -

Don't use the paper's edges for borders; draw the four borders instead. Keep it small.

- - -

Look for and plan the all-important white shapes. Place the midtones around them. Are these whites interesting shapes? Can they be combined into fewer, simpler shapes? Would a diagonal movement make it more exciting?

- - -

Is there a large dominant shape such as a big sky or foreground? What about really pushing this idea with a sky that takes up 80 percent of the space? That would certainly eliminate putting the horizon in the middle of the painting as we are all wont to do. Combining a cluster of trees or a group of people into one larger shape will help simplify the composition.

- - -

Add the darker shapes as needed. Another darker value or two sketched in should be enough.

- - -

Time to try another. Don't quit now! You've just warmed up!

Contour Drawing

Before I begin with the values, I draw a quick, loose contour drawing to capture the gesture of the figure. Gesture and contour drawings are excellent ways to prepare for painting.

Contour drawing is an outline of the shapes connecting them to the border, inside forms and each other. It's a good way to find the relationships between objects. Gesture drawing is the quickly sketched lines that can capture the simple or sometimes exaggerated movement of a figure.

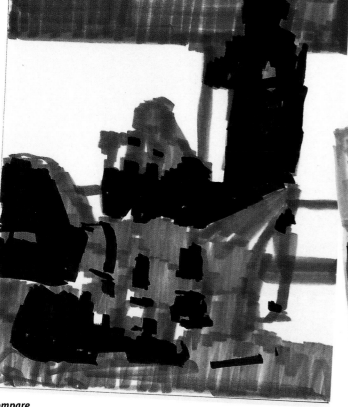

Compare

I used two gray markers and a black marker for these small thumbnails in order to determine how to best approach this painting. Making a shape is easier with the broad tip of a marker than it is with a pencil. Note that a border has been indicated around the design. Shapes are defined using these edges.

These were just a beginning, a glimmer of an idea or concept. Either one of these could have been developed into a value study and then into a painting. I continued on with the thumbnail of the seated figure. It needed to have some adjustments, connections and simplification, but I thought it had some potential, so I took it to the next stage of development.

THE VALUE STUDY

Value studies are slightly larger, painted versions of the thumbnails in which you try out various approaches to decide where to place the lights, midtones and darks.

Many artists determine their painting's values using a thumbnail, but I've found that the process of pouring requires more preplanning than regular painting techniques. Because you'll need to preserve the white paper with masking fluid, these shapes have to be carefully designed and assigned that value. Unless you have a map of your values, you can easily lose your way.

Value studies may be relatively small, fitting on an 11" × 14" (28cm × 36cm) piece of paper (with a border of white paper around the outside edges). The clean backs of old watercolors are good surfaces to start working in paint.

If you have a really fine design in a square format, don't try to do a rectangular value study. If you don't like the format, go back to the thumbnail stage, as I chose to do with the painting to the right.

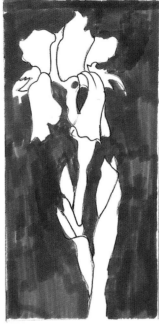

Positive or Negative? Decisions, Decisions
Samples of value studies. One is a positive shape on a negative background; that is, a dark flower on a light background. Here the area around the flower would be masked and the flower poured. In the second study, where the flower is light and the background dark, the flower would be masked and the background poured. These are simple compositions, almost like roughs, and have design flaws, but they do help illustrate the thinking process necessary in preparing to pour. They are ideas made visible, subject to approval or change.

The Result
I decided to go with a dark background and a lighter group of irises. I masked the flowers before adding the final dark values. In addition to helping me decide the value arrangement, the value studies above served their purpose by pointing out some composition problems. In the vertical format, the iris touches only one border. The negative shapes were unvaried, so I tried another value study using a horizontal format. This design has more shapes that touch the borders and created a greater variety of negative spaces.

WILLIAMSBURG IRIS
14"× 20" (36CM × 51CM)
PRIVATE COLLECTION

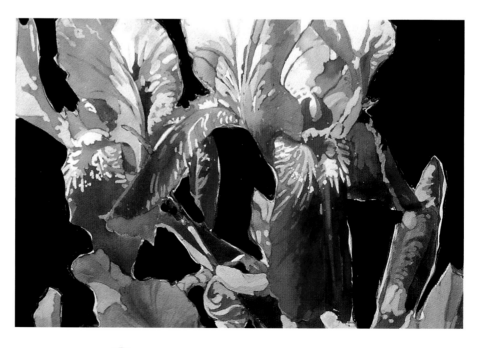

Create a Value Study

These quick little studies in one hue will benefit any painter and especially one who pours. In pouring we mask instead of painting around the shapes we want to save. Otherwise the thinking process of going from light to dark and the sequence of steps is the same. Once you have this concept in mind the process of masking and pouring will become much clearer.

Making these small value studies in just one hue is great fun. They can be beautiful little monochromatic pieces of art that can stand on their own.

You'll need a paint that can produce a dark value. Yellow wouldn't be nearly dark enough and red tends to be a middle value. Blue or black, however, can be thinned for the lighter values and remain undiluted for the darker values. Even the steps of mixing paint in a cup or saucer will help you transition to pouring.

These little studies can be addictive and will certainly advance your skills in seeing shapes and values and placing them into a good design pattern.

MATERIALS

Basic Materials on page 18

PIGMENTS
Da Vinci Phthalo Blue
or
M. Graham Ivory Black

Four Values
Here are the three values I apply to the value study. With the white paper, we have four values used in the value study.

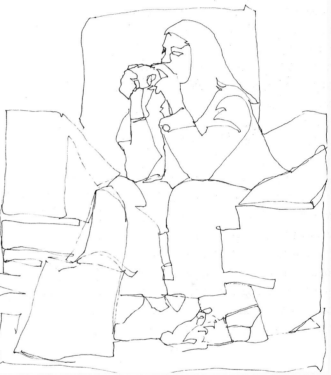

1 CREATE THE PATTERN OF SHAPES

Sketch the design on the watercolor paper in pencil. The paper doesn't really need stretching; just tape or staple it to the board. Sketch or transfer (page 64) the design to the watercolor paper, keeping the proportions the same as the thumbnail. The thumbnail has a good design, so keep the same shapes in the value study. If you're not comfortable transferring the drawing, instructions on scaling up to a larger size are on pages 62-63. Once you have drawn in the design, place masking tape around the edges of the design to establish the border.

2 ADD THE SECOND VALUE

Mix a light wash of the blue or black paint in the plastic cup. Are there any lumps? Keep mixing until the paint is totally smooth. Test on a piece of watercolor paper. This value should be just darker than the whites.

You may notice on the sketch that the white shapes are marked with Xs; these serve as a reminder to not put paint on those areas. With your 1-inch (25mm) flat, paint around the white shapes, covering everything else with the first wash. Let everything dry thoroughly.

You now have two values. The shapes have hard edges and are flat.

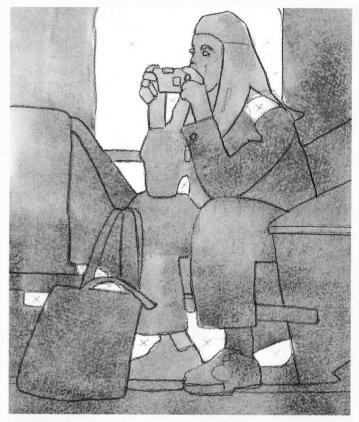

3 ADD THE THIRD VALUE

Add enough paint to the previous mixture to make the next darkest value. Check again to see that there are no lumps. This mixture should be about a midtone—darker than the first wash and lighter than the darkest final wash. Once again test this color on the watercolor paper. Refer to the thumbnail to see what light shapes you want to paint around. You can pencil an X on those shapes, too, if it helps you avoid them.

Use your 1-inch (25mm) flat to cover everything but the whites and the lightest values. Let everything dry thoroughly. The painting now has white shapes, light shapes and midtone shapes: three values.

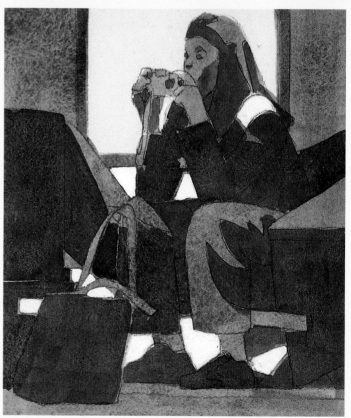

▓ WATCHING THE WHITES ▓

Need more white areas? They have a way of disappearing. If they have, take some white acrylic or watercolor or gesso or gouache and put these whites back in. Now, isn't it reassuring that you can make changes if you've somehow covered up a shape you should have painted around?

60

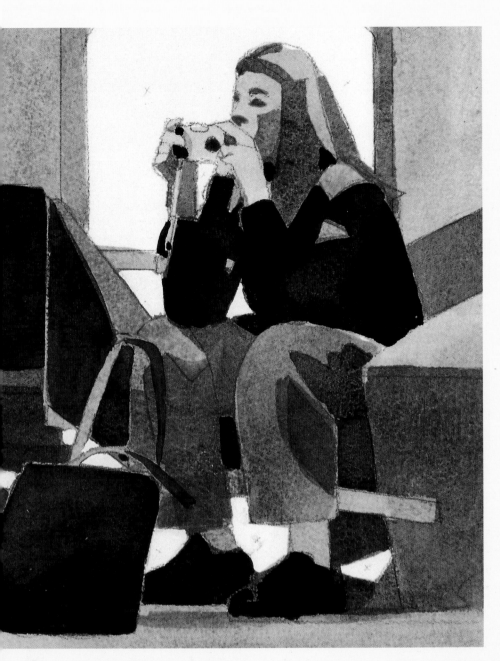

4 ADD THE DARKEST VALUE

Add more paint to the previous mixture to mix a really dark value. Again check this for lumps and then test it on the watercolor paper. How does it compare to the two previous washes? Remember it will dry somewhat lighter. If you want to mix this final, darkest value on a palette instead of adding more paint to the other washes, that will work fine. This dark value is the one that makes the painting work. Look at the thumbnail to decide the dark valued areas. Take some time to think where you want these strong darks. Can you connect some darks? Several small dark spots scattered about may confuse the viewer. Using the 1-inch (25mm) flat should keep you from painting too many small details. The small round brush is just for the necessary final touches. Usually the darks work best at the center of interest or forming a movement toward that area.

> ■ THE VALUE ■
> OF DARK VALUES
>
> Compare the study to the previous step. Many of us are fearful of darks and end up with ho-hum paintings. The darks are effective in bringing life to a painting.

Enlarge the Design

A time-honored method of enlarging a drawing is to use a grid. I divide the small drawing or value study into a combination of vertical, horizontal and diagonal lines, then draw the same lines on the larger paper. Whatever shapes appear in one section on the smaller paper, you can reasonably reproduce in the matching section on the larger paper.

Enlarging directly on the watercolor paper can be intimidating, especially since too many erasures can damage the surface. A good compromise is to first enlarge the drawing onto tracing paper. Tracing paper has an added bonus: If you need to make changes or correct a mistake, just place another sheet of tracing paper on top, save the good stuff and lose the bad.

I use my tracing paper like a security blanket. If a painting is less than I'd hoped for (or maybe I decided to try it with a different color palette), the drawing is there on the tracing paper ready to be transferred to a fresh sheet of watercolor paper. You don't need to go through the whole drawing process again unless you want to.

MATERIALS

Small value study or pencil drawing to be enlarged

Watercolor paper

Gator board

Stapler and staples

Tracing paper

Long straightedge

Ruler

No. 2 pencil

Masking tape

1 PREPARE YOUR PAPER AND INDICATE BORDERS

Stretch the watercolor paper on the Gator board and let it dry. Draw lines to indicate the borders, then place masking tape on these borders to cover the staples. (I used blue tape here.) Set it aside.

2 SUBDIVIDE THE VALUE STUDY

Use a ruler and a no. 2 pencil to lightly draw two diagonal lines across the study from corner to corner. This should help you find the center of the paper. (I used a red pencil because it's more visible for you.) Draw a horizontal line through the center. Do the same with a vertical line. To be sure the vertical and horizontal lines are straight, measure the distance from the center to each border. This process may be repeated as often as needed to give you additional reference points.

3 PLACE THE TRACING PAPER

Place a piece of tracing paper over the stretched watercolor paper. Make sure the tracing paper is large enough to cover the entire watercolor paper. Tape the tracing paper to the board along the top so it will not move, then trim off any excess. Find the edges of the masking tape on the watercolor paper underneath. Draw lines on the tracing paper to show these edges.

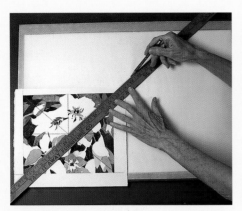

4 ESTABLISH THE HEIGHT OF THE PAINTING

Place the value study in the lower left corner, making sure the edges align. Place a long straightedge (a standard ruler will be too short) over the diagonal you've already drawn on the value study. With your pencil, extend this diagonal line from the lower left corner of the value study to the upper right of the tracing paper until you run off the edge. This is the height of the painting.

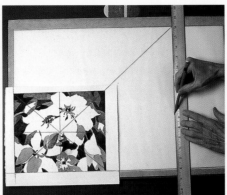

5 ADD THE FOURTH BORDER

Drop a vertical line down from this last point. You have now completed the four borders on the tracing paper. It is now a larger size but in the same proportion as the value study.

■ PHOTOCOPIES AND ■ OPAQUE PROJECTORS

Other ways exist to enlarge or scale up a design besides the grid. For instance, many of my students will have a photocopy of the value study made into a larger format. Another method is to use an opaque projector to enlarge a photo or drawing, but these can be awkward to use. I prefer the grid on tracing paper as it gives me a chance to refine the design and get familiar with the shapes. Each time you draw the design, you have the opportunity to improve and enhance it.

■ ENLARGING HINTS ■

Don't want to draw grid lines on the value study? I solve this by putting a piece of tracing paper over the value study, too, and drawing the borders and lines of the design. You are interested only in enlarging the lines around the shapes, not with their values. We are making a larger drawing, not a larger value study.

This may all seem a bit complicated. It really isn't; the first time you use the process, it becomes clear.

The simpler the design, the easier it is to enlarge—another excellent reason to "keep it simple, student."

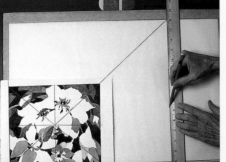

6 COMPLETE THE GRID

Remove the small study and draw in the part of the diagonal that had been covered by the study. Using a series of horizontal, vertical and diagonal lines, divide the value study into a reasonable number of areas. Duplicate this grid on the tracing paper overlay.

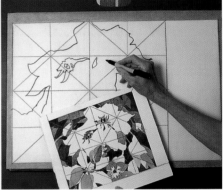

7 USE THE GRID TO PLACE THE SHAPES

Place the objects on the tracing paper overlay where the value study indicates they should go. Do this by locating their place in the grid and duplicating those lines on the tracing paper. I use a pen here, but it's a better idea to use a pencil. It isn't necessary to deal with any values, right now; just transfer lines.

Without having to deal with complicated formulas, you have completed a drawing on tracing paper. The proportions are correct and just the right size to fit on the watercolor paper. Everything is ready to be transferred to the watercolor paper!

TRANSFER THE DRAWING

AFTER YOU HAVE ENLARGED YOUR DESIGN TO FIT THE WATERCOLOR PAPER, YOU WILL NEED TO TRANSFER THIS DRAWING TO THE WATERCOLOR PAPER ITSELF. Two simple ways exist to do this: graphite paper and the light box.

GRAPHITE PAPER

Graphite paper has one side covered with the graphite while the other is untreated, similar to carbon paper. This type of transfer paper can be purchased or made by the artist. To make graphite paper, cover the back of a blank piece of tracing paper with a 6B pencil, then rub it with a cotton ball treated with lighter fluid (do this in a well-ventilated room). This sheet may be used many times.

Graphite paper tends to smudge, so use the smallest piece you can and place it only where you are working. Use a sharp pencil to transfer the lines. Lift the tracing paper and graphite paper to see if the lines are transferring dark enough. A kneaded eraser easily removes any light smears of graphite.

Of the commercial graphite paper, the Saral brand works well but can be a bit messy. Look for the type that is wax-free, or you will find the design lines will act like a resist.

LIGHT BOXES

For years, I taped my drawing and watercolor paper to a window in my studio. This worked fine for smaller pieces, but my arms and neck would get tired! After I acquired a light box, which uses the same principle, things went much more quickly and easily. When using a light box, you need to draw the design on the paper before you stretch the paper on the board. The light box has proven to be a wonderful tool for altering drawings on tracing paper as well as transfers and slide viewing.

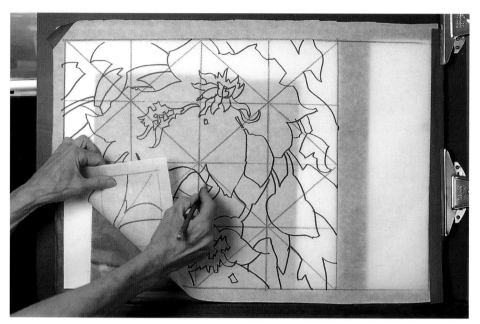

Transferring With Graphite Paper
Place the tracing paper drawing on the stretched watercolor paper. Tape it along one edge so it won't move. Slip a sheet of graphite paper between them with the graphite side down.

Transferring With a Light Box
When using a light box, place unstretched watercolor paper on top of the tracing paper drawing. It's best to tape the drawing to the light box first and then tape the watercolor paper over it. It's easy to see through the watercolor paper to the drawing. Since the tracing paper drawing here was drawn in marker, it's even more visible.

MASKING TECHNIQUES

TO PRESERVE AREAS OF OUR TRANSPARENT WATERCOLORS, WE PAINT AROUND
THESE SHAPES. BUT THERE'S ANOTHER OPTION—MASKING FLUID.

Masking fluid is usually temporary and therefore removable. Its purpose is to form a barrier between the paint and the paper. In addition to masking fluid, we can also use masking tape, contact paper, masking film, wax crayons, candles and watercolor (washout) tape. Some of these materials were obviously meant for different purposes but are also useful as art supplies. Using a mask frees the artist to pour, spatter, splash, tilt, drip and paint spontaneously. When these areas—whether thin lines or large shapes—are saved, the composition is not lost to the free-flowing and expressive actions of watercolor.

MASKING WITH A BRUSH

It's important to use the right brush to apply masking fluid. The ammonia in masking fluid will damage brushes with natural hair, but synthetic brushes have a slick finish that protects it. Even using an old brush made of natural hairs isn't a good idea. It will become a clump of masking fluid and no longer be a responsive masking tool. Using the right brush and treating it properly will produce well-covered areas with well-defined edges. Remember that the white shapes in the painting are the most eye-catching, and they should be masked with care.

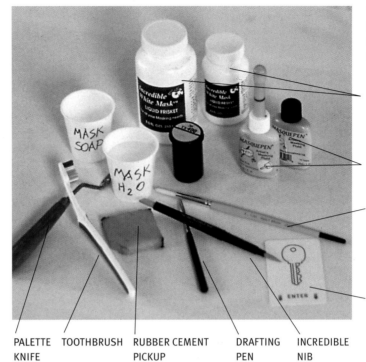

Tools for Masking
Shown here are some materials for masking and creating texture.

MASKING FLUID

MASKING FLUID
PEN AND REFILL

SYNTHETIC BRUSH

ROOM KEY OR
CREDIT CARD

PALETTE KNIFE TOOTHBRUSH RUBBER CEMENT PICKUP DRAFTING PEN INCREDIBLE NIB

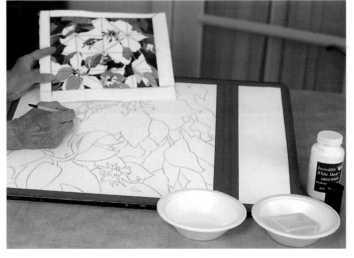

Masking to Protect the Lights
I apply masking fluid with a Taklon brush made especially for this purpose. It holds a good amount of mask and comes to a sharp point. These brushes are available in a variety of sizes and in both rounds and flats, though I prefer rounds. You should also keep a dish of water, a dish of soap and a film can for masking fluid on hand, as well as the value study for reference.

▓ A MASKING ROUTINE ▓

To keep the masking brush in good order, either dip it in liquid soap or rub it on a bar of soap before using. My routine is to put the brush in water, then the soap, then back in the water. Only after this, when the nylon bristles are satisfactorily coated with soap, do I dip it in the masking fluid. After a few trips to the masking fluid, I'll repeat the dipping process. If you follow these steps, you'll find the brush lasts longer. As soon as you finish masking, wash the brush with soap and warm water. If you find yourself masking a good bit, stop every now and then to wash the brush out thoroughly. Discard the masking water as soon as the masking is complete.

BEFORE YOU MASK

MASKING CAN CREATE PROBLEMS AS WELL AS SOLVE THEM.

Some papers have a softer surface that may tear when the mask is removed. The 140-lb. (300gsm) paper handles mask better than the 300-lb (640gsm). Before starting a painting, always test the paper by applying the masking agent, letting it dry, then removing it. If you don't wait for the mask to dry before pouring or if the paper is damp when you add the mask, the surface may be damaged. Arches paper in the 140-lb. (300gsm) weight is forgiving, but even this strong paper will tear if you hurry things too much. Some of the softer papers can be precoated with matte medium to protect them, but this changes the way the paint reacts on the surface. The best thing to do is to test your paper and be patient. Patience is not just a virtue but a necessity.

The First Mask on White Paper
I applied the masking fluid where I wanted to preserve white or light areas. As it dried, the mask turned from a white to a cream color, which makes it easier to see if the mask has covered smoothly. After the mask has dried, it's a good idea to mask with a second layer to cover any pinholes or dry brushstrokes.

■ USING LIQUID MASK ■

Check mask to be sure it is white or light in color. It should be creamy in consistency with no lumps. Do not shake. To mix, drop in a marble and swirl gently.

Put the word *mask* on a disposable cup and fill partway with water. Use this cup only during the masking process to rinse the brush.

Pour the mask into a film canister. Replace the top on the bottle of mask.

If using a brush to mask, use nylon, not natural fibers. Prepare the brush for masking by first wetting with water. The brush can then be coated with liquid or bar soap to protect it from the mask. Every few trips to the masking fluid, dip the brush in water, then soap. Try to keep the fibers free of clumps of mask. If you see clumps, immediately rinse the brush in warm water and soap.

Apply the mask in smooth even strokes. Don't brush back and forth. Since the mask shrinks as it dries, pinholes and weak spots occur. After the mask dries, these become visible, and you can cover them with another coat of mask.

Let this dry thoroughly. If you use a hair dryer, put it on a low setting and keep moving the dryer. Drying in the sun may make the mask hard to remove. It is better to be patient and let it dry overnight. Even when the mask looks and feels dry, the paper may still be damp under the mask.

OTHER MASKING TECHNIQUES

YOU CAN COMBINE SEVERAL OTHER MASKING TECHNIQUES WITH
THE MASKING FLUID, OR USE THEM SEPARATELY.

TAPES FOR SHAPES

Tapes are wonderful for creating geometric shapes. Masking tape is an old favorite of mine, but other equally good new choices are Scotch blue painters' tape and Specialty Tapes' Water Color Washout tape. The Washout tape is made to stretch paper, but it can also mask shapes before pouring. For some reason, the tape works best on white, unpainted paper. Paint seems more likely to bleed under the edge of the tape if the protected area is already painted.

MASKING FOR TEXTURE

For texture, you can mask using wax crayons or candles, simply rubbing them over the surface. Spattering masking fluid is a good way to simulate sand or snow. For line work, apply masking fluid with string, palette knives, toothpicks or a drafting pen. Once you start, you'll discover all sorts of wonderful tools.

A VARIETY OF MASKING TECHNIQUES

Palette Knife
I dipped the knife in masking fluid and used the edge. By pushing down and turning the knife, I formed a curved line.

Stamp With Masking Fluid
For this design, I coated a stamp with liquid mask using a sponge. I immediately cleaned the sponge with soap and water. I pressed the stamp to the dry paper and then cleaned the stamp. When the mask dried, I applied red paint. Once the paint was dry, I lifted the mask.

Washout Tape
I cut shapes out of Washout tape, then applied red paint. When the paint dried, I removed the tape. I cut smaller pieces of the tape, then added them to the white shapes. Then I applied lavender paint. After it dried, I removed the tape.

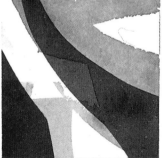

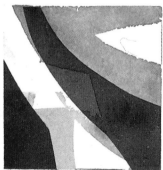

Washout Tape and Wax
I applied the two tape shapes from the sample at left and covered the paper with blue paint. After this dried, I lifted the tape. At this point, I rubbed a wax candle over the paper on the bottom left, then added gray paint.

Spatter of Liquid Mask
Here, I wet an old fan brush with water and dipped it in mask. To spatter the paint, I dragged the handle of another brush across the fan brush's bristles. Once the mask dried, I applied a layer of blue paint. When the paint had dried completely, I lifted the masking fluid.

Credit Card
I dipped the edge of a room key card into masking fluid. After this dried, I added red paint. I think another layer of mask and paint would have made it more interesting.

MIXING AND POURING PAINTS

THE WATERCOLOR PAPER HAS BEEN STRETCHED AND DRIED; THE COMPOSITION
DECIDED AND TRANSFERRED TO THE PAPER; MASKING FLUID HAS BEEN
APPLIED... Time for a little "chaos" after all that patient planning!

MIXING THE PAINTS

First, you need to squeeze some paint from the tube into the plastic cup. How much? A teaspoon? A tablespoon? The answer is: As much as you'll need. A big painting requires a greater amount of paint, and a small painting needs less. A stronger, more intense color needs more paint, a tint less. Those are therefore two factors to consider—strength and quantity.

When it comes to strength, the ratio of water to pigment determines how intense the color will be. Generally, I suggest pouring the lightest values first. From there, you can add more pigment to the mix so that subsequent pours become progressively darker. You can always add more pigment, but you can't really remove any.

As far as quantity, it's wise to mix a surplus of paint rather than run out partway through the pour. It's too late at that point to stop and mix more. Leftover paint, on the other hand, can be made stronger and used for the next pour.

After you squeeze the paint into the cup, add just a bit of water and mix with the brush until smooth. (It's best to have a designated red brush, blue brush and yellow brush for mixing.) Add more water to produce the amount and strength needed for the first pour.

Test the paint by brushing a swatch on watercolor paper. Wait until it dries. Remember, paint dries lighter than it looks, especially when added to wet paper. Better to make it a bit darker than the planned value.

Mix each color in a separate cup. The yellow should be at its most intense in this first pour—intense, but still transparent. It needs to be strong to have a chance to influence the mixtures. Red and blue, being darker values, have no trouble making themselves important in the blends. They will need more water in their mixtures for the lighter pours.

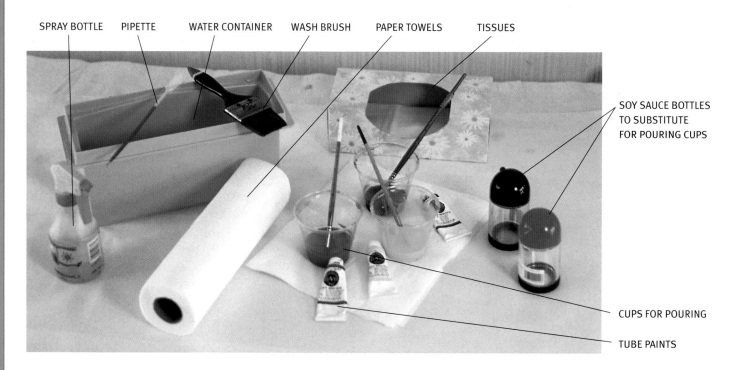

SPRAY BOTTLE PIPETTE WATER CONTAINER WASH BRUSH PAPER TOWELS TISSUES

SOY SAUCE BOTTLES
TO SUBSTITUTE
FOR POURING CUPS

CUPS FOR POURING

TUBE PAINTS

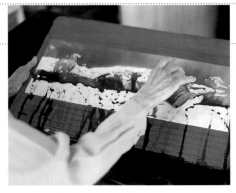
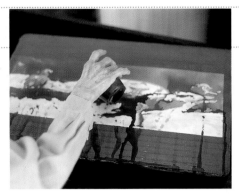
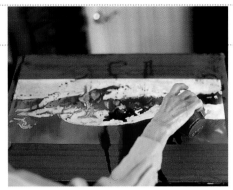

Pouring Paint
Here, I pour yellow and red, then flip the painting to pour blue.

POURING THE PAINTS

Before pouring the paint, you must first wet the paper all over. The paints need a layer of water over which to float and blend. Use the tissue to blot up any excess water from the tape. Pour while the paper is shiny.

Pour yellow first, then red and then blue. For areas you intend to keep warm, pour yellow and red there. Cooler spots should have some blue as well as the yellow and red. The paints flow with the movement of the water layer, and the tipping of the board will decide this movement. If you tip the board too much, moving it back and forth, the paints are apt to blend into a neutral color. It's better to keep the board flat at first and let the colors sink through the water layer and stain the paper. Then they may be poured off.

POURING OFF THE PAINT

If the puddles of paint are left to dry on the board, they lose transparency and may dry with a crusty look. It's necessary to pour off the paint while it's still shiny. The paint has done its work and stained the paper. Leaving it on the paper any longer will not make it darker, just less luminous.

What manner of movement would best suit the painting? Tip the board to make the paint flow in that direction. A diagonal is exciting, a horizontal calming and a vertical stately. Think about how you will pour off in advance so the darker pigments won't flow over the lighter hues. Planning will help prevent this.

Keep the board vertical until the paints no longer drip off the bottom. If it's placed flat too soon, blossoms may occur. Clean off the taped edges and masked shapes.

A

B

C

D

How Strong? A Balancing Act
In all of these examples, I first wet the paper and poured all three primaries while the paper was still shiny.

A. Equal strength. All the colors are equal in intensity. Because the yellow is lighter in value, I had to mix a thicker yellow and a thinner red and blue to get equal intensity.

B. Overpowering red and blue. The yellow here is thin, and the red and blue are thicker. The red and blue are far more intense.

C. Warm blends. For a warm influence, I used a thicker yellow and red and a thinner blue.

D. Opaque yellow. Once the red and blue pours were dry, I wet the paper down and poured a thicker yellow. The thick yellow might appear as a grainy drift of paint on the darker colors. This isn't a pretty sight.

MASKING AFTER THE FIRST POUR

AFTER THE FIRST POUR DRIES, CHECK THE VALUE STUDY TO SEE IF THIS FIRST POUR IS DARK ENOUGH.

If not, add more pigment to the cups. Test to see if this mix is stronger, then wet the paper and pour again. To maintain the clarity, try to keep warm colors on warm and cool colors on cool.

If you're pleased with the first pour, it's time to protect the next lightest value with masking fluid. Any shapes you want to remain this value, protect with masking fluid. Remember, it's important to allow the paper time to dry between masks and pours. If possible, let it dry overnight. Masking too soon will lift the color underneath, sometimes even tearing the paper. If the paper is cool to the touch, moisture is still present. Wait until the paper is totally dry before adding the masking fluid.

Continue the process as in the previous steps, adding more pigment to the mixtures each time. Keep in mind that the yellow must stay transparent and probably won't need to be too much more intense. When the layering is finished, let everything dry thoroughly and remove the masking fluid.

MASKING NEIGHBORS

Mask can be added between steps, and also removed. If you have two neighboring shapes to mask, but one will have the masking fluid lifted before the other, you need to plan ahead. If the two shapes are masked with no border or separation between the two, both shapes would lift off in one solid piece. It would then be necessary to remask the one shape.

To prevent this, leave a dam of paper with no mask between the shapes. The mask can be taken off one shape and remain on the other shape. A side benefit to this is the resulting line work—when the pour flows between the two masked shapes, a slight line of color will appear. These lines can be seen in *Parthenon* on page 44 where I masked the sky and then poured the shape at the final stages.

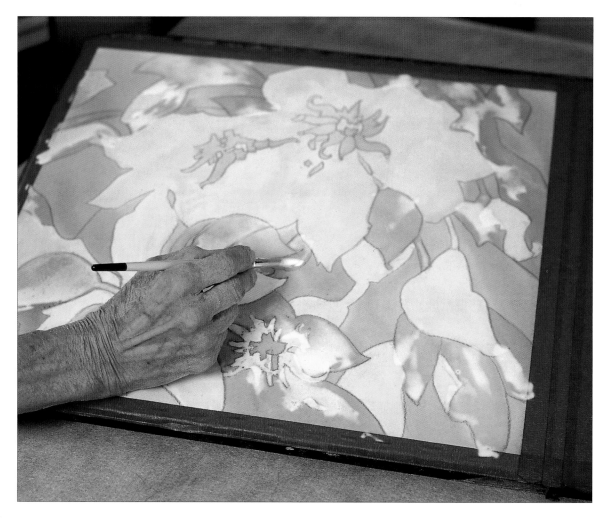

Mask After the First Pour
After the first pour is totally dry, I apply masking fluid to any areas I want to keep this light color.

THE NEXT POUR

AFTER THE NEW LAYER OF MASK HAS DRIED, YOU CAN POUR THE NEXT VALUE.
ADDING MORE PIGMENT TO THE PREVIOUS MIX WILL WORK.

Make sure you have enough of each mixture ready to pour; again, you can't stop to mix more paint midpour.

The example I've been using has only two pours, but you can continue to mask and pour as long as the painting stays lively and luminous. Once the paint starts looking heavy and thickly layered, the beauty of the pours is lost.

REMOVING THE MASK

Removing the mask should be a quick and painless process. To keep it painless, keep a few things in mind. It will be easier if you applied the liquid mask generously rather than too thinly. Also, don't allow the mask to dry in the sun, because it can become permanently attached to the paper that way. Larger pieces are easier to remove than smaller pieces, so plan around that as best you can.

To remove the mask, lift a corner with your fingers and peel the shape. Peel up the mask slowly at first to make sure the paper surface is not tearing. A square rubber cement pickup works well in lifting paint. In a pinch, a piece of used masking fluid formed into a ball will also lift the mask. Avoid the white shapes as best you can because the paint could smear into these areas. And keep pieces of mask out of clothes and off carpets. It's hard to remove from fabrics!

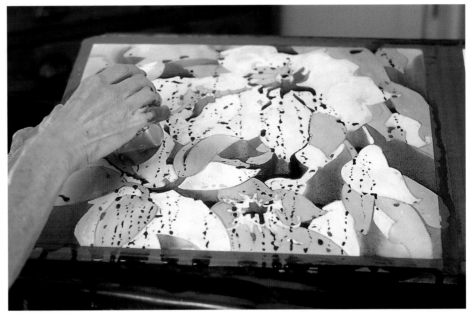

Pour Again
The second pour should have more pigment to make it a stronger, darker value.

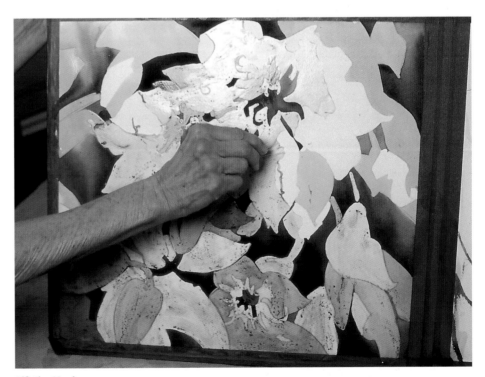

Lift the Mask
The mask can be peeled off easily by lifting a corner. To avoid smearing the paint, hands should be clean.

DIRECT PAINTING

AFTER THE POURS HAVE BEEN COMPLETED, YOU MAY DECIDE THAT YOUR PAINTING NEEDS NO BRUSHWORK AT ALL (AS WAS THE CASE WITH *PARTHENON*, PAGE 44).

Usually, though, a little dark brushwork is like frosting on the cake. If small shapes need to go darker and you want to pour them, great! Unfortunately, this might require a lot of masking. If the area is delicately placed, you might rather use brushwork. Another reason to use brushwork rather than pours is that brushwork allows you to place sparks of unifying color, like a bright red or yellow to perk up a painting.

Brushwork needs to be unobtrusive. It should look like part of the painting, integrated with the pours. For direct painting, use flat brushes for glazes or rounds to add spots of color and linear detail.

Because the paper surface has had so much abuse, it will be more absorbent. It may even act like a blotter, and the edges of paint strokes may appear fuzzy. By mixing the paints to a thicker consistency, it will be easier to make a clean stroke. The pigments you mixed in the cups for pouring will be too thin for brushwork.

Watch where you place strokes of color. Putting strokes of a cool blue over a cool poured blue-green will ensure that the color stays vibrant. A red over the blue-green would dull the color. This step is a lot of fun; as a result, it's easy to do too much with the brush. Less is more at this point.

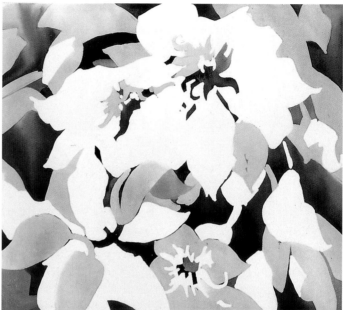

The Mask Is Off
When all the mask is removed, the white paper has a chance to shine. Now you can evaluate the painting and determine what's needed to complete it.

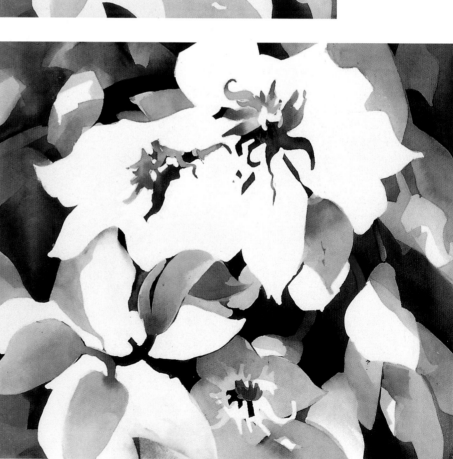

The Completed Painting With Brushwork
The painting is completed. In this chapter we have followed this piece from value study to tracing paper to watercolor paper, through two maskings, two pours and a bit of brushwork.

CLEMATIS
14" × 16" (36CM × 41CM)

WOVEN PATTERNS
BY LINDA BAKER
30" × 42"
(76CM ×107CM)

Well-Planned Masking and Pouring

Multiple layers of masks and pours created this rich color and dimension. To achieve this level of success takes great skill, strong commitment to the painting and a good deal of planning. This painting was completed with multiple pours. Throughout the pouring and masking process, Linda added and lifted separate shapes. Since she needed to lift one masked shape without accidentally peeling up the neighboring masked shape, it was necessary to leave dams of unmasked paper. The dams resulted in darker lines of color around the shapes.

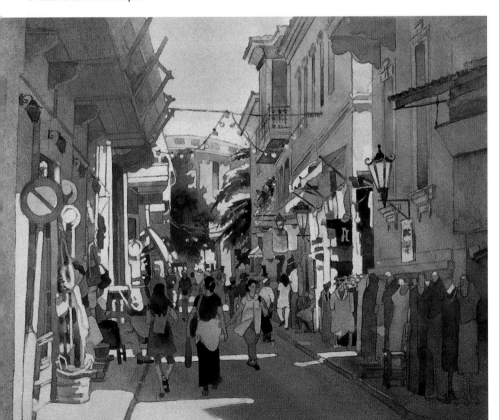

Mask Over Color

You can apply masking fluid over poured color, but when you peel it up, some of the color may be lifted, too. Staining colors will not be as fragile as nonstaining, and deeper colors will fare better than pale tints. In the foreground is a lady with a sweater around her hips. That area was poured and then masked. I knew that the masking fluid would lift some of the color and was pleased with the paler result.

ATHENS AFTERNOON
20" × 26" (51CM × 66CM)
COLLECTION OF DALE ZIEGLER

VARIATIONS ON MASKING AND POURING

THE STANDARD MASKING AND POURING PROCESS I'VE JUST WALKED YOU THROUGH WILL SERVE IN MOST CASES, BUT SOMETIMES IT'S GOOD TO TRY A VARIATION ON THAT THEME.

LARGE SHAPES OF LIGHT VALUE

Normally with large shapes of a light value, such as a sky, you would pour at the beginning and then mask the area. Since mask can lift color, though, this large shape may become uneven. To solve this problem, apply masking fluid to the large sky shape at the beginning. After all the pours are finished, lift the mask from the sky area, leaving the other masks where they are. Since some masking fluid residue is often left in large shapes, it's a good idea to wash the sky with a soft brush and lots of water before pouring. Mix together a light pour (the previous cups of paint will probably be too dark) and pour the tint over the sky. Once this tint is dry, you can lift the masking fluid from the other shapes.

PARTIAL POURS

Another pouring technique is a partial pour. When an area of the painting needs to be changed, a glaze of color may be the answer. For example, darkening the area around a light shape will bring that area into focus, or spotlight it. To do this, first wet the paper all over. Tip the board and pour only on the areas away from the shape. This technique can also be used to calm a too-busy foreground. An overall glaze of a single color can visually connect diverse shapes. To try highlighting different areas of your painting, move a flashlight around on it. You might discover a totally unexpected center of interest.

WASHOUTS

Sometimes the paint can get a bit thick on the paper and we feel the need to reclaim some light shapes. "Washing back" to the previous layers, or even the white paper, is possible. If your painting has an overall loss of transparency, the solution may be a trip to the tub of water. You can gently remove the top layer of paint by taking the painting off the board and immersing the painting. A bit of careful brushing can dislodge deeper layers. You can also soften edges this way and even lift the staining colors. As soon as the paint is as light as you wanted, drain off the excess water and stretch the paper back on the board. The colors will be glorious. As soon as the surface is completely dry, make any changes that are needed.

WASHOUT TAPE DIRECT PAINTING LIQUID MASK

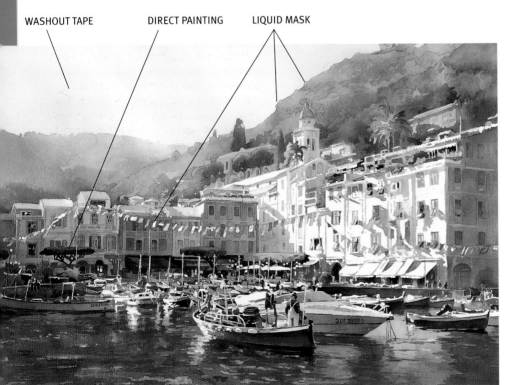

A Large, Light Value

In the beginning, I used washout tape to protect the sky shape from the various pours. I sealed it around the edges and along the top of the mountains with masking fluid to prevent paint from leaking under the tape. The pour itself went diagonally from the top left corner to the lower right corner. After all the pours were completed, I removed the tape and mask from the sky. At that point, I did one last, light pour to complete the sky.

PORTOFINO
25 ½" × 40"
(65CM × 102CM)
COLLECTION OF SUSANNE RUSSELL

Washout Calligraphy
For this painting, I poured staining colors—Red Rose Deep and Phthalo Blue. When the pours dried, I placed a stencil on the painting, and then wiped across the stencil with a soft damp sponge until the shapes emerged.

SHAPING UP

Paint can also be removed from a small shape that has gotten too dark. To do this, place tape (masking tape, washout tape or painters' tape) around the area you plan to wash out. Take a damp soft sponge, squeeze it until it's almost dry, and then wipe paint from the shape to be lightened. Pat this dry with a tissue. Repeat as needed, but be careful; if you rub too vigorously, you can damage the paper. This technique also works well to break up large dull shapes into more interesting, smaller shapes.

OPAQUE MEDIA

Yes, I know we are transparent watercolorists, but nothing makes the transparent pours appear more transparent than the contrast of opaque pigments. They are a wonderful adjunct to our luscious, airy veils of color. These opaque touches appear in the work of Winslow Homer and John Singer Sargent, so why not yours and mine? To use gouache or gesso, designer colors or white ink is not a bad thing. If it's applied with care and intelligence and furthers the personal vision of the artist, it's a worthwhile material. It also creates the freedom to paint with greater spontaneity, which is a good thing.

These suggestions for additional techniques are just that. You may find that the steps of masking and pouring transparent watercolors offer enough ways to express your creative ideas. If not, try some partial pours, opaque media or washouts. As you paint, you'll find yourself responding to what is happening on the paper. With time and practice, you'll have a whole inventory of creative solutions for painting problems.

Opaque Pigments
I covered the painting with several transparent pours, giving color to the background, donkeys and foreground. After these layers dried, the background and foreground were direct painted with opaque pigments to simplify them. I originally wanted to use transparent washes, but they just wouldn't cover, so the opaque paint was a necessary step. The white paper defines the light on the donkeys' backs, harness and bundles.

DONKEYS ON AMORGOS
14" × 20" (36CM × 51CM)
PRIVATE COLLECTION

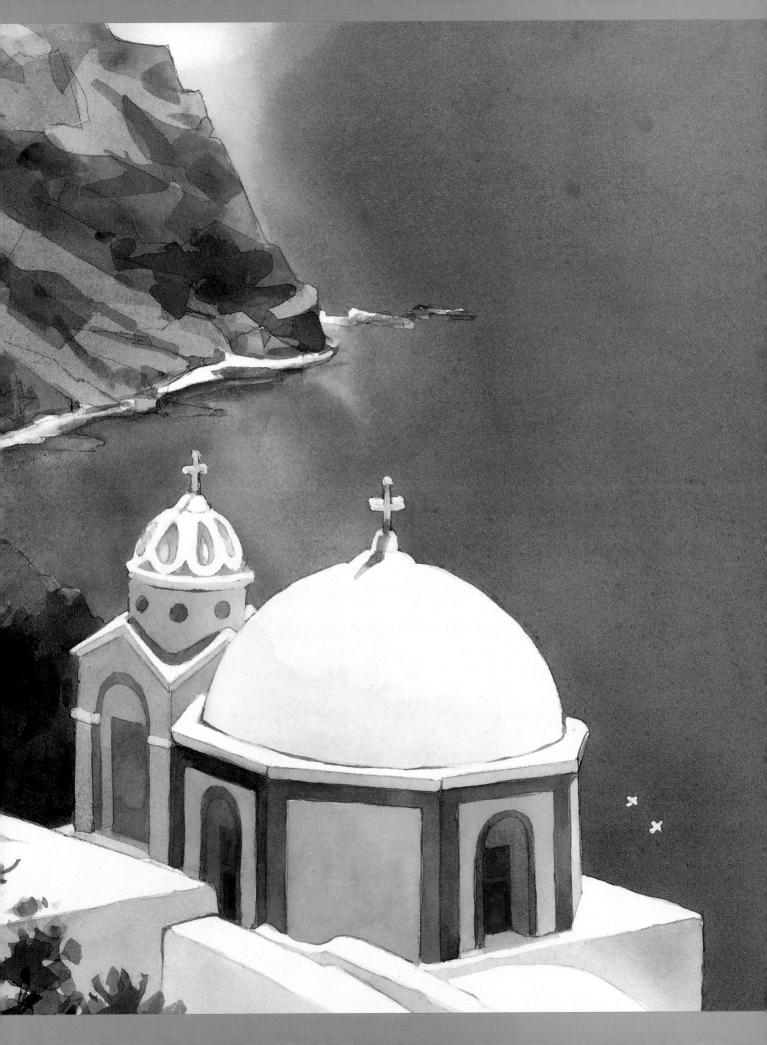

5 DEMONSTRATION: POURING LIGHT STEP BY STEP

The following chapter has examples of the materials and techniques I use for masking and pouring watercolors. The paintings are subjects that have been part of my experiences traveling and at home. While the demonstrations are helpful regarding these particular paintings, they'll also give you ideas on how to respond to your own environment. The purpose of the demonstrations is not to just show you how to paint a palm tree or a beach scene; they also offer suggestions for weaving the background and foreground together or planning and masking large shapes. These lessons, though they may be about beaches and palm trees, teach you the skills you'll need to paint your own world, which may include pine trees and mountains. Try the suggested colors and techniques, but don't stop there. Build on these lessons with your own images and innovations!

SANTORINI SEAS
16" × 22" (41CM × 56CM)

Santorini Seas
Layering Glazes of Transparent Watercolor

By masking and pouring, you'll progress from white to light to darker values. You'll break up some of the larger shapes into midsizes and add the smallest details with brushwork. This is a traditional way of working in transparent watercolor—from large to small, light to dark, and simple to detailed.

As the three primary colors combine on the wet paper, all the hues of the spectrum will appear in unusual blends and unexpected places. The large shape of the water showcases this and makes an exciting contrast to the white dome.

Look through your resource file of photos and sketches, and seek out those with large areas where you can pour on the color and watch it flow.

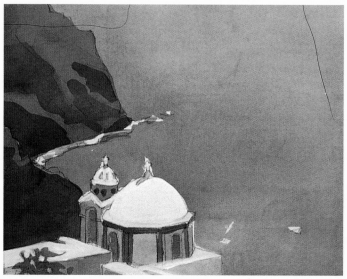

Value Study
Refer to this as you mask and pour.

MATERIALS

General Materials on page 18

POURING PIGMENTS
Da Vinci Red Rose Deep
Da Vinci Phthalo Blue
Da Vinci Hansa Yellow Light

DIRECT PAINTING PIGMENTS
Da Vinci Brown Madder (Quinacridone)

1 TRANSFER THE DRAWING

Once your paper is stretched and dry, transfer your drawing to the watercolor paper and establish the borders with masking tape, making sure the tape covers the staples. Make pencil lines dark enough to be seen through multiple washes. Avoid erasing anything; you might damage the paper surface.

2 MASK THE LIGHTEST VALUES

Using your masking brush, mask the white paper where you'll want to preserve the lightest values. These lights will be an important part of the composition. Allow the masking fluid to dry. Wash the masking fluid off your masking brush, using soapy water.

> **■ VALUABLE VALUE STUDIES ■**
>
> If you find yourself not sure where to apply masking fluid in your painting, refer to the value study. If you've created a value study with the lights, midtones and darks clearly placed, you should have no trouble finding the next areas to mask.

MASKING MAP

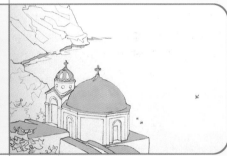

3 WET THE PAPER

First, mix and test your three pouring pigments. For this first pour, you'll be pouring just the three primaries. Apply a layer of clean water across the entire paper using your 2-inch (51mm) flat brush. The pours need this layer of water to float across. If you forget to apply it, hard edges will occur when you pour. Make sure the surface is completely covered. You'll wet the paper before each pour from this point on.

4 APPLY THE FIRST POUR

Since yellow is the lightest value of the three primary colors, pour the Hansa Yellow Light mixture first. Add it to the buildings, rocks and water. Leave some areas of white paper here and there.

Immediately pour on the Red Rose Deep. Tip the board so the left side receives more paint. Again, leave some areas without paint.

Pouring the blue can be scary. You don't want the blue mixture too strong, so dilute the Phthalo Blue well. If you have mixed it a little too strong, all is not lost. Just quickly throw on some of the Hansa Yellow Light or Red Rose Deep and add another layer of more diluted Phthalo Blue. Keep the Phthalo Blue on the right side of the painting by tipping the board.

Keep the board tilted to drain the excess paint into the tub. Continue until it stops draining. If you put the board flat too soon, you may end up with backruns or blossoms. Blot the edges of the tape with a tissue. Let the paint dry thoroughly.

> ### ■ POURING TIPS ■
>
> If you keep rocking the board, the pours mingle too much and become an overall neutral color.
>
> You will be pouring Red Rose Deep, Hansa Yellow Light and Phthalo Blue, going stronger each time. Watch the Hansa Yellow Light. It can get opaque if it's too thick.
>
> Test your colors before each pour.

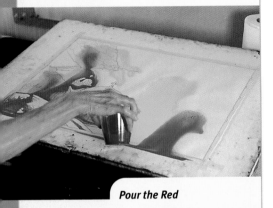

Pour the Yellow

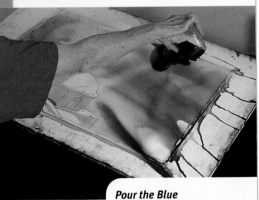

Pour the Red

Pour the Blue

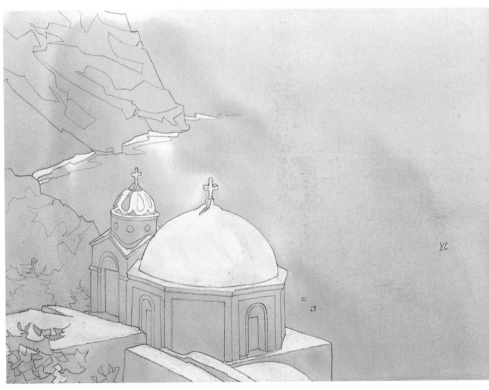

Drain the Excess

5 MASK FOR THE SECOND TIME

When the first pour is completely dry, the colors will appear much lighter. Mask any areas where you want to save the color you just poured. All the unmasked areas will receive the next poured layer of darker colors. After applying the masking fluid with your masking brush, wash the brush in soapy water. Let the masking fluid dry completely before moving to the next step.

▨ PATIENCE, PATIENCE ▨

Have you been patient and allowed that first pour to dry? If you add mask too soon, it will lift the beautiful colors of the first wash. Waiting overnight works!

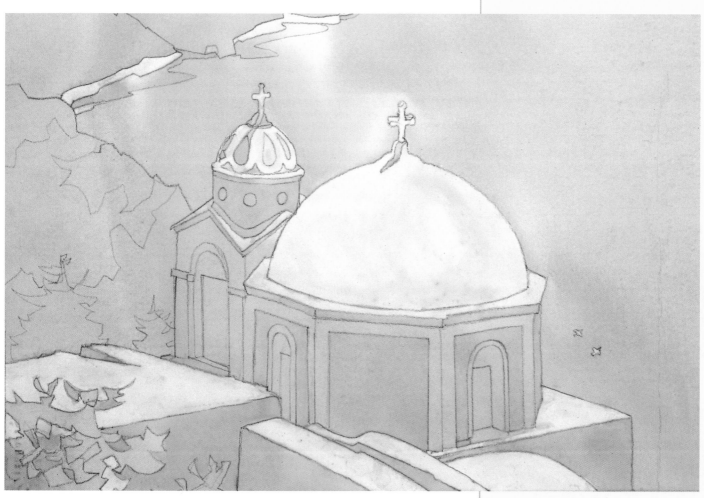

MASKING MAP

6 APPLY THE SECOND POUR

Mix fresh batches of the three pouring colors, but this time use less water so the colors are stronger. Now wet the entire paper with your 2-inch (51mm) flat brush. Starting with Hansa Yellow Light and ending with Phthalo Blue, pour the three colors in about the same places as before—warm on warm and cool on cool. Colors stay clear and are less apt to neutralize if you control the flow. Drain the excess paint into the tub and then let the painting dry.

While the painting dries, look it over. Can you see three values? You should see areas of masked white paper, some areas masked after the first pour and all those other areas that just received the second pour. Compare it to the value study. Are you on the right path?

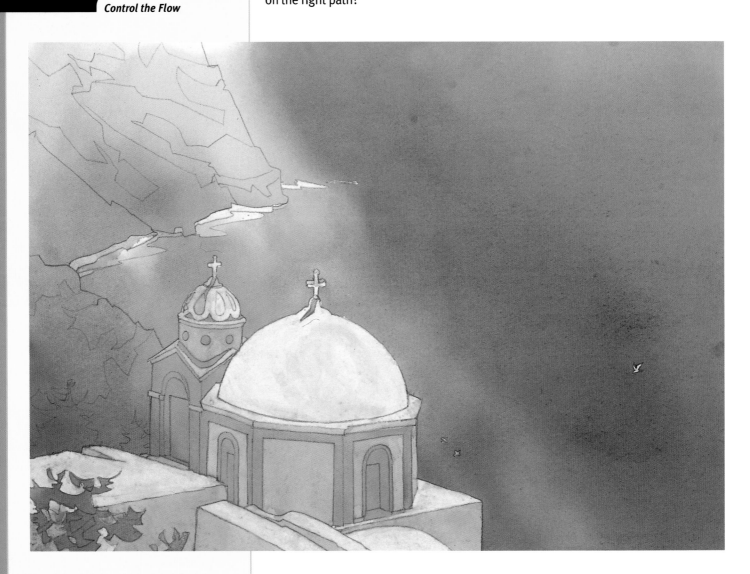

Control the Flow

7 MASK FOR THE THIRD TIME

This is the third time to choose some shapes to save. If you get confused, simply go back to your value study. You can change your mind along the way, of course, but it's good to have a plan if you need it. Cover the shapes you decide to keep with masking fluid. Have you washed the masking brush frequently and kept it free of dried mask? If not, try to clean it or use a fresh one.

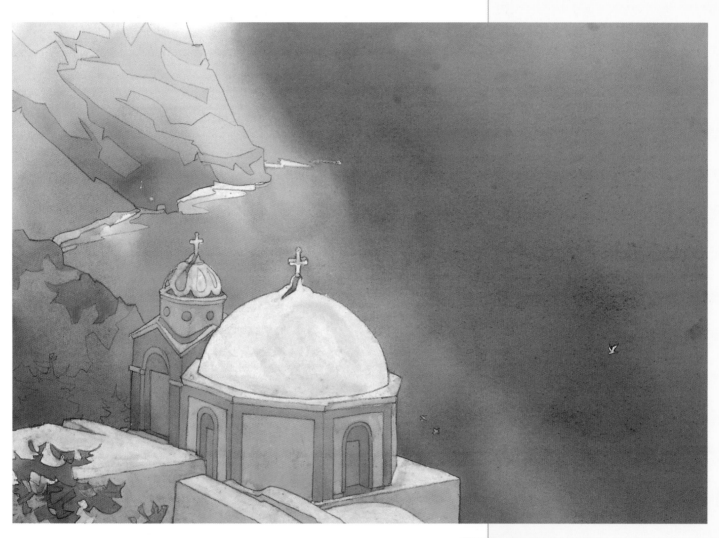

MASKING MAP

8 APPLY THE THIRD AND (MAYBE) LAST POUR

By now, you're a pro at pouring. You've mixed some good rich colors with no lumps and remembered to wet the paper before each pour. Keep it up!

Mix new batches of all three colors. Pour the Red Rose Deep and Hansa Yellow Light mixtures on the warm rocks and church. You can also pour a little bit of Phthalo Blue on the church and rocks. For the sea, fearlessly go for a rich Phthalo Blue. If you get in trouble, spray on some water and try again. As long as there is a shiny layer of water, you are free to keep adding paint.

Tip the board and keep it tipped as long as paint is draining. Blot paint from the border tape with a tissue. Those pesky backruns can hurt your beautiful pour. Take the time to get rid of excess paint before you lay the board flat. Be extra patient; let your painting dry completely. Overnight is good.

If the now dry color isn't strong enough, wet the paper, mix thicker paints and pour again while the mask is still on.

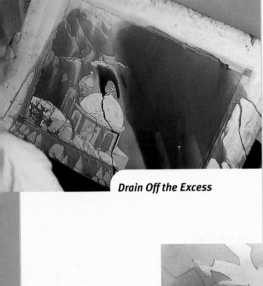

Pour Yellow, Red and Blue

Drain Off the Excess

■ IF YOU GO ■ TOO FAR...

Since this pour uses strong colors, stand by with your spray bottle! If things get too dark, tip the board and hit the offending area with the spray bottle while the pour is still wet. Keep the board upright so the excess paint will run off the paper.

You can also lift some of the paint with a brush. Make a "thirsty" brush by wetting it with clean water and squeezing out the excess water. Touch the brush to the too-dark wash and the paint should lift right up. You might be tempted to lift with a tissue, but that can make the surface too dry and can leave an ugly edge.

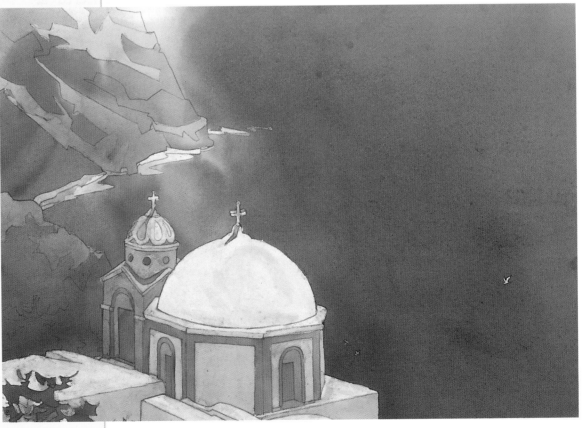

9 REMOVE ALL THE MASK

What fun! At last, you can see pristine white paper. To remove the mask, lift the edge and pull it up. Smaller shapes may need to be coaxed off with the rubber cement pick-up. Avoid rubbing and smearing paint into the white areas.

The result can be a surprise. The edges are hard, and things may look a bit unfinished. Well, they are. All is fine. The painting just needs some dark values to give it that final zing.

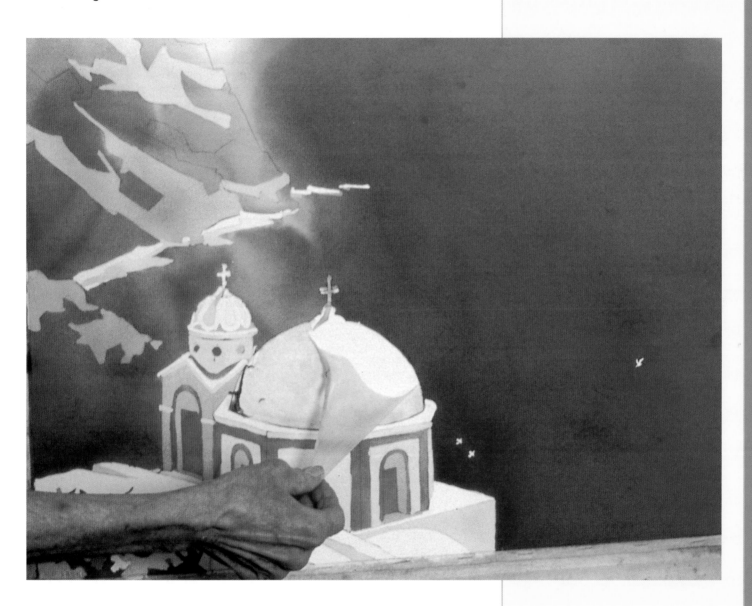

10 ADD DETAIL WITH DIRECT PAINTING

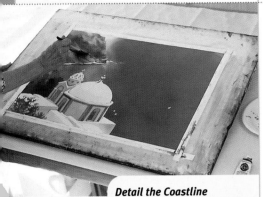

Detail the Coastline

Detail the Buildings

Spend some time just looking, then break out the brushes and put some paint on the palette. Along with the three primaries, you'll need Brown Madder (Quinacridone). Correct and soften any rough or hard edges.

Use the 1-inch (25mm) flat and the 2-inch (51mm) flat brushes to add some dark rock shapes to the hills. Using the no. 6 round brush, strengthen the detail on the building. Try mixing the Brown Madder (Quinacridone) with the Phthalo Blue. If this looks too muddy, glaze with the Red Rose Deep and Phthalo Blue. It's exciting to see the pours shine through these glazes. Let the layers dry between glazes. It's best to use one quick pass of color so the brushstrokes don't disturb the poured first layers. Put a mat around the painting.

After you're satisfied, don't do too much to the painting; poured pieces have a special beauty that doesn't need a lot of fiddling.

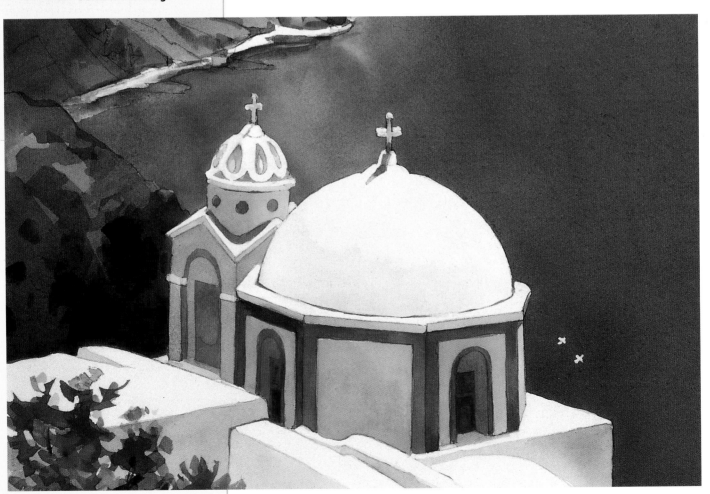

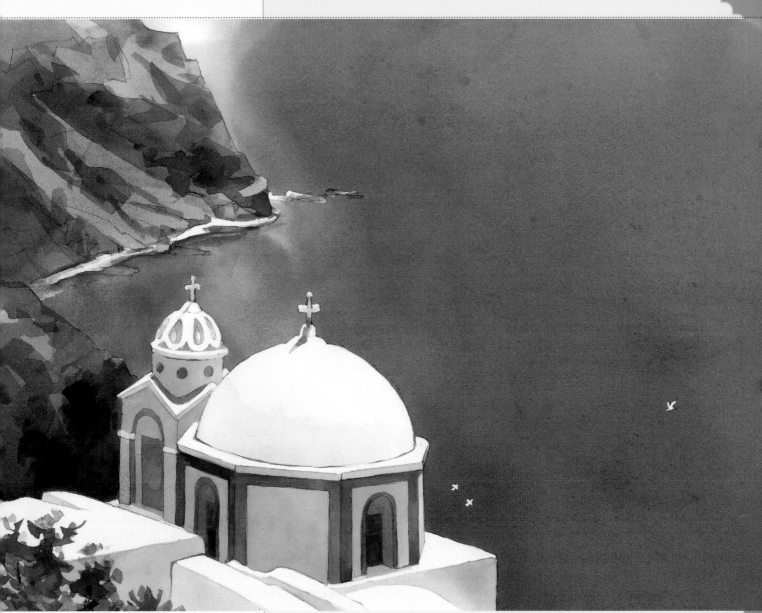

SANTORINI SEAS
16" × 22" (41CM × 56CM)

DESIGN SUMMARY

The overall design pattern is a large midtone
with a midsize light and small darks.

Repetition is present in the *shape* of the circles in the dome and small windows. The *direction* has
a circular movement; the eye goes into the painting along the edge of the church back to the white
wave along the rocks and then to the right, down to the small birds back out of the painting. The
rocks and sea combine into a large midtone, resulting in a *unity* of *value*. *Contrast* of *color* between
the warm church and the cool sea helps create depth. *Contrast* of *size* is also evident as the tiny
birds fly over the water. If you cover the birds, you'll realize how they kept your eye from going right
off the edge.

I could've done some things better. This painting has no strong *dominance* of *color*. The left side is
predominately warm, and the right side is mostly cool. Perhaps adding cool shadows to the church
would help *unify* the painting.

Dappled Palm
Weaving Background and Foreground Shapes

Many of us have trouble with the subject having a "pasted-on" look. By masking the background sky along with highlights on the tree at the start, you'll be working to weave all areas together. These light areas will be tinted and painted later. This will help connect the background and foreground shapes.

This painting uses some special techniques. The masking, for example, needs to be done so that neighboring masked shapes may be removed separately. Other steps will involve direct painting, spattering and washouts.

Value Study

MATERIALS

General Materials on page 18

POURING PIGMENTS
Da Vinci Hansa Yellow Light

Da Vinci Phthalo Blue

Da Vinci Red Rose Deep

DIRECT PAINTING PIGMENTS
Da Vinci Brown Madder (Quinacridone)

1 TRANSFER THE DRAWING

Transfer the drawing to the stretched and dried paper. If the pencil lines look too light, darken them. Make sure your pencil lines are strong enough to last through the washes and that your masking tape borders cover the staples.

2 MASK THE LIGHTEST VALUES

Using your masking brush, mask the areas that need to be protected from the first pour. Don't forget to clean the brush with the water and soap after each use. Refer to the value study to make sure you cover all the light shapes. Let the masking fluid dry before proceeding.

MASKING MAP

3 APPLY THE FIRST POUR

After testing your mixtures, apply a layer of water to the paper with your 2-inch (51mm) flat brush. Pour all three mixtures, from yellow to red to blue, and allow them to blend. If you think the colors are too dark, remember they will dry a lot lighter. Drain off the excess paint and let the painting dry thoroughly.

Pour the Colors

4 APPLY SECOND LAYER OF MASKING FLUID

Add masking fluid to the next series of shapes. By doing this now, you'll preserve some of the lights on the palm trunk and save the color of the first pour on the coconuts. Think about weaving these lights throughout the piece. When you mask the coconuts, leave a narrow, unmasked band of paper between the coconut shape and sky. When you later remove the mask from the sky, you won't disturb the neighboring masked shapes.When you're satisfied, allow the masking fluid to dry completely.

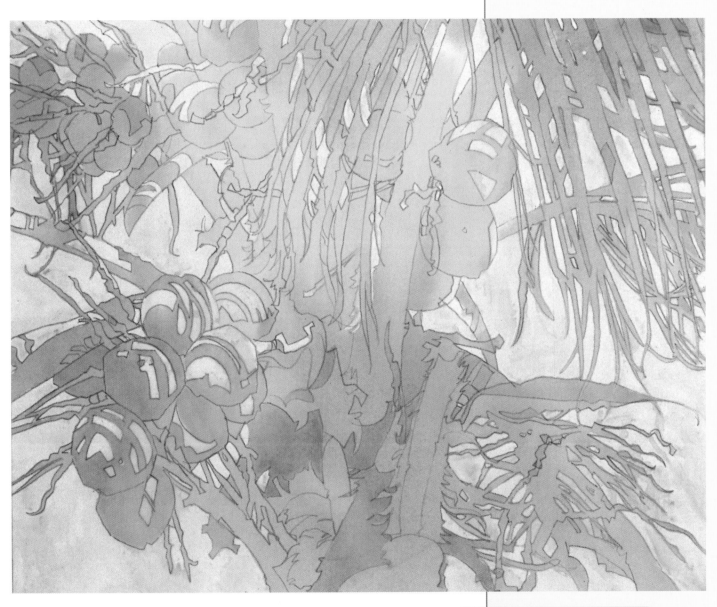

MASKING MAP

5 APPLY THE SECOND POUR

Remember to wet the paper with your 2-inch (51mm) flat brush. Mix a stronger version of each primary color, then pour the paint. After this pour, it should be easier to see the difference in the values. Can you find the three that are there so far? The lightest values are still covered with mask, and they don't look like white paper at this point. Drain the excess paint into the tub and then wait for the painting to dry completely.

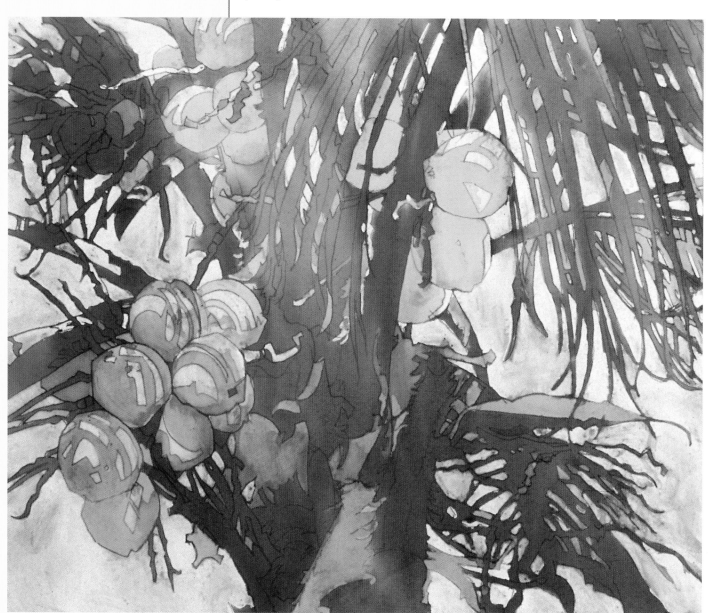

6 APPLY THE FINAL MASK

For the third (and probably final) layer of mask, find the areas to preserve by consulting the value study and by studying the painting itself. Because I liked some of the warm areas in the trunk, I masked them out. Save some of these good shapes, values and colors. Let the masking fluid dry completely.

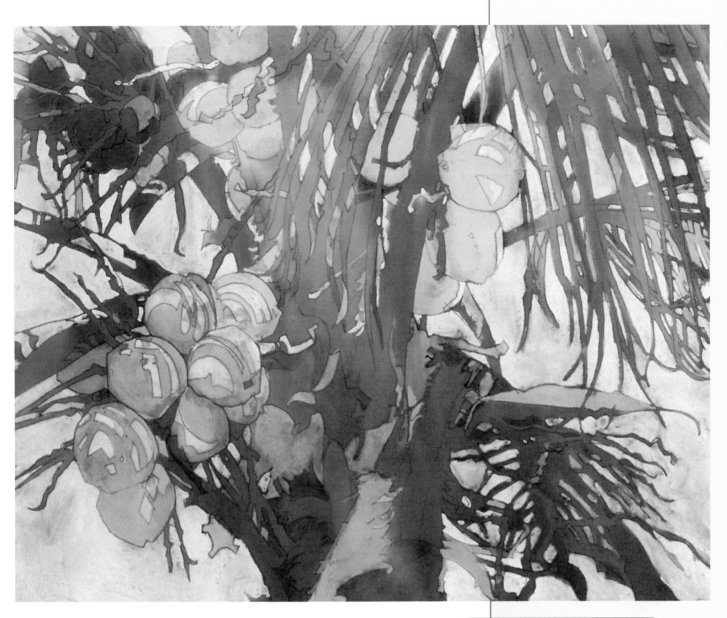

MASKING MAP

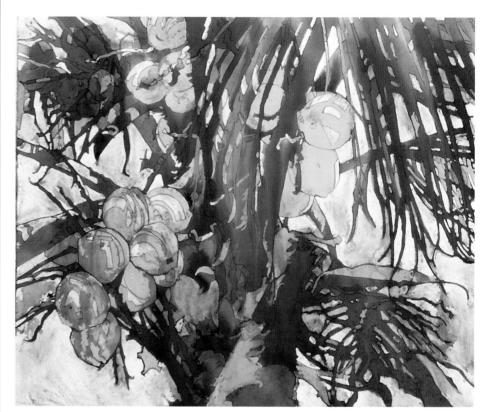
Peel Up the Masking Fluid

7 WET THE PAPER AND POUR AGAIN

At this point, many students are anxious to pour and may forget to wet the paper. Don't let yourself forget. Wet the paper with a layer of clean water, using your 2-inch (51mm) flat brush. This pour should be a darker value, so mix the paints stronger than the last time. Stir the pigments well; this pour needs a dark value, but it must also pour smoothly. The Hansa Yellow Light is the most likely to lose transparency and become chalky, so you may have to make it thinner than the Red Rose Deep and the Phthalo Blue. Pour all three colors and blend. Drain the excess from the paper and let the painting dry.

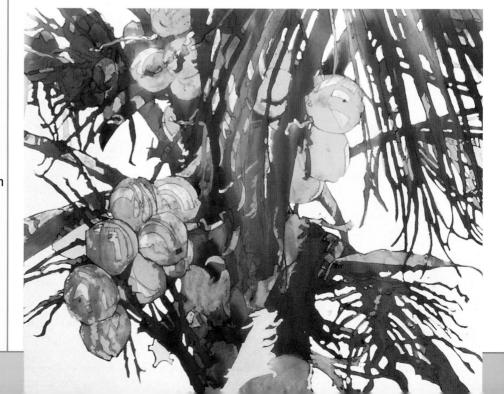

8 REMOVE THE BACKGROUND MASK

Peel the mask from the background areas behind the palm. Also peel up the large foreground shape on the trunk. Leave all the other masked shapes covered. If you find that some of the neighboring foreground shapes are being pulled up when you lift sections, you can use a razor blade to cut the mask. You may need to reapply mask to some of these areas.

9 TINT THE BACKGROUND

Wetting the paper will remove excess paint and any residue of mask. This is important; if even a little of the mask residue remains on the background, the paper rejects the pours. Keep washing down until no more paint comes off. You may like to try a spray bottle to help with this step.

Create the three primary color mixes, but keep them lighter than the last pour. At this point, you're just adding some color to the background. Wet the paper with clean water and your 2-inch (51mm) flat brush. While the paper is wet, pour all three colors. When you washed down the painting, it also softened hard edges. Is the paper resisting the pour? If so, use the 2-inch (51mm) flat brush and very carefully cover these areas. Allow the painting to dry.

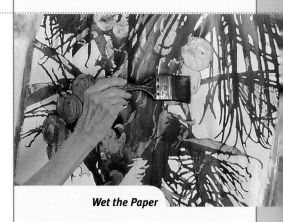

Wet the Paper

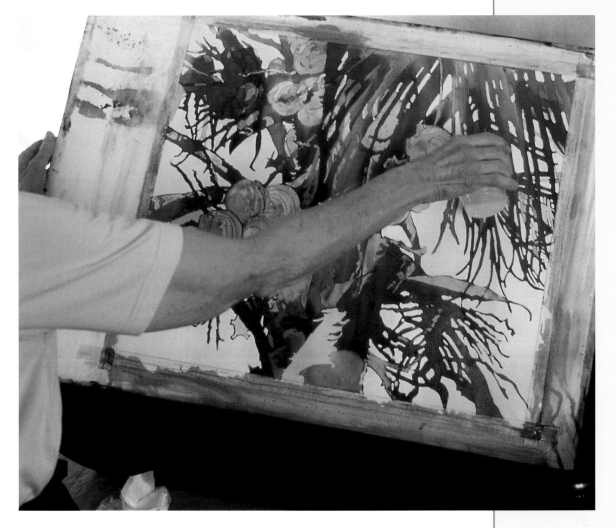

95

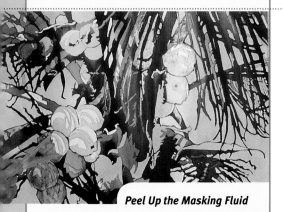

Peel Up the Masking Fluid

10 REMOVE THE REMAINING MASK

Remove all the rest of the mask from the coconuts and the other shapes on the palm's trunk. A lot of color may come up with the mask, which is why you should use stronger paint mixtures for areas that will be masked. If these areas seem too light, don't be concerned. With direct painting, you can add more color, so don't burn those brushes yet!

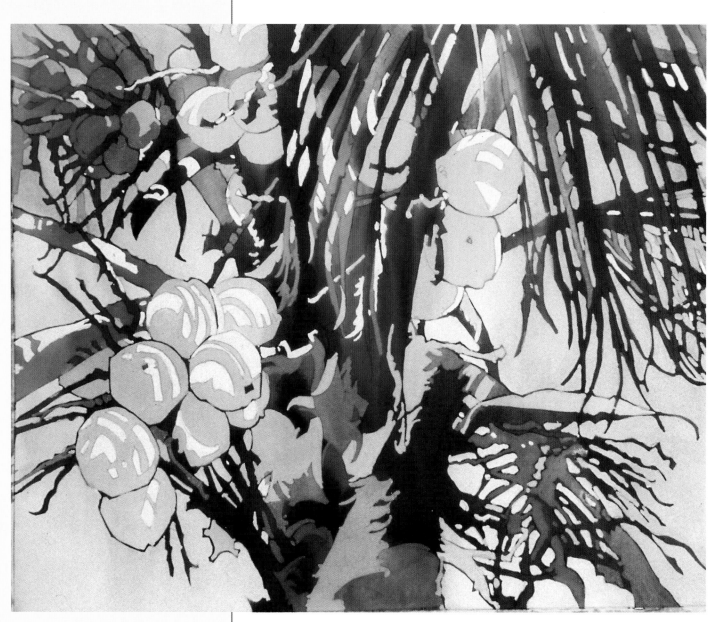

11 ADD DARKER VALUES WITH DIRECT PAINTING

After taking a good look at everything so far, it's time to add the darker values. Put Phthalo Blue and Brown Madder (Quinacridone) on a palette. These colors will create warm and cool dark values. The pigments in the cups may be too diluted for direct painting, but they'll work well for some lighter glazing. Use the 1-inch (25mm) flat for large washes and the no. 8 round for detail. Refer to the value study but trust your intuitive skills, responding to what you feel is needed in the painting.

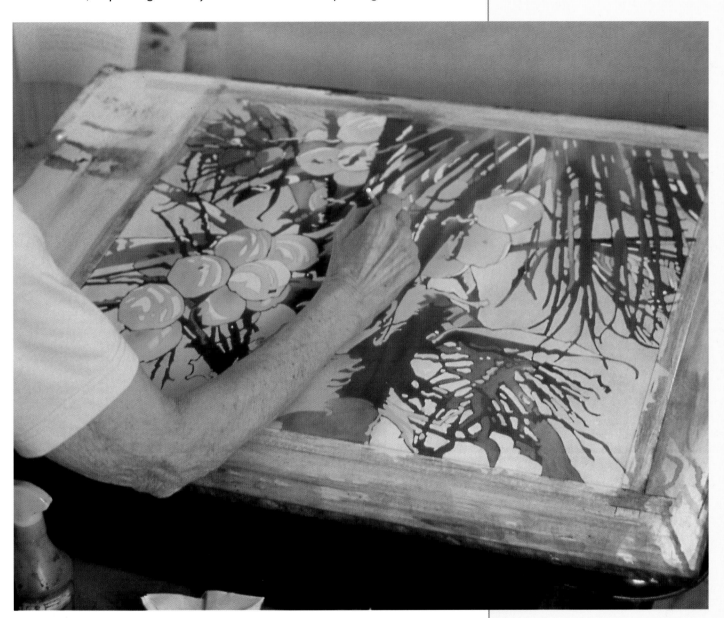

12 LIGHTEN AREAS AND ADD TEXTURE

To wash out any areas that need to be lighter, place masking tape around the shape. Wet a soft sponge and wring it out until it's almost dry. Gently blot out the paint. Repeat as needed.

Add some texture on the coconuts and trunk with spatter. To protect the other areas from stray paint spatters, cover the other areas with paper towels. To spatter, load your no. 8 round brush with paint. Hold the loaded brush over the selected area and tap it against another brush. Try varying the color of the spatters.

Blot With Sponge

Spatter for Texture

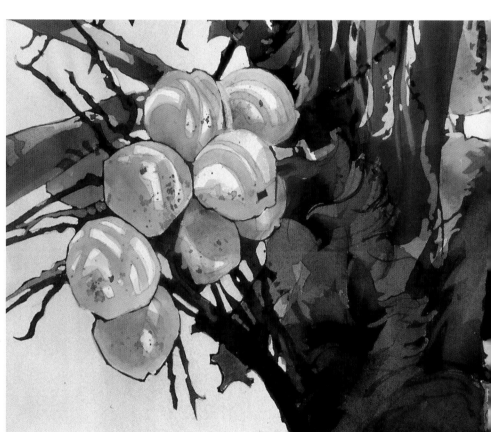

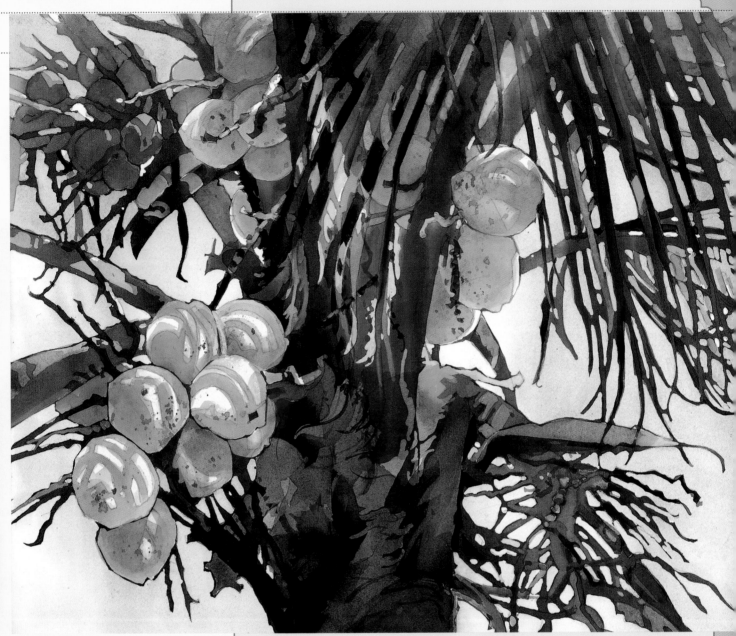

DAPPLED PALM
18" × 21" (46CM × 53CM)

DESIGN SUMMARY

The design pattern is a large midtone with some darks and small lights on a light background. I made an effort to integrate the palm and background sky by pulling some flickering lights into the tree. The small lights on the coconuts are important to this design.

Between the round fruit and the linear fronds, there is *contrast* of *shape*. The *direction* provided by the flowing *line* of the fronds adds *movement*. *Repetition* is also present in the *direction* and *size* of the fronds. The negative shapes between the fronds vary in *size* and *shape*. The *dominance* of *warm colors* is *contrasted* by the *cool colors* in the sky. Each of the four corners is a different *size*, but a formal *balance* is achieved in the centering of the palm. The growth pattern of the branches provides the *rhythm*. *Texture* from the spattering of paint *contrasts* with smooth washes.

What changes would I make? The palm tree's trunk is centered both vertically and horizontally. The coconuts on the left and the frond on the right create a visual line splitting the painting into quarters. (We are such orderly folks!) An *asymmetrical balance* might be more interesting and would produce a greater variety of sizes in the background shapes.

Shell Beach
Pouring Color on Large Shapes

In this beach scene, folks stroll and collect shells as they enjoy a colorful sunset. Most of us have experienced that special, quiet time on a beach in the evening. In this demonstration, we'll use pours to create that twilight beauty.

Notice that the large shapes are masked before the pours. I have some special reasons for this rather unusual procedure.

First, it's better to mask large shapes of a lighter value at the beginning. If they were poured first and then masked, their colors might lift unevenly when the mask is removed. Mask always lifts some color, but that isn't a problem in the smaller shapes. This is noticeable only in large shapes, such as the sky and beach.

The second reason is that I used a different approach in this painting. I started with the middle values, which become darker with each pour. After I finished most of the pouring, I added the darkest values with brushwork. When the mask is finally removed from the large shapes of the sky and beach, mask will still remain on the whites and lightest shapes such as the water. We are then free to pour the glorious colors in the sky and beach. When these colors go over the other darker shapes, they enhance them and bring everything into harmony.

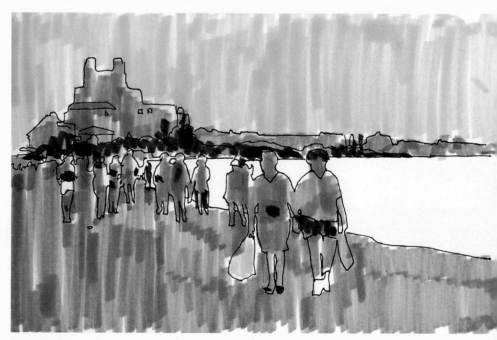

Value Study
For this demonstration, I picked a subject that had large shapes that I could mask at the beginning and pour color over later. Skies, hills and foregrounds work well with this technique.

1 APPLY THE FIRST MASK

Transfer the drawing to the stretched watercolor paper. Mask out all the areas that you would like to save. Look at the value study to help you decide. As you can see, you need to mask three large shapes—the sky, the water and the beach—as well as the smaller shapes. After the masking fluid dries, add a second layer so the pour won't leak through the pinholes. Let the masking fluid dry.

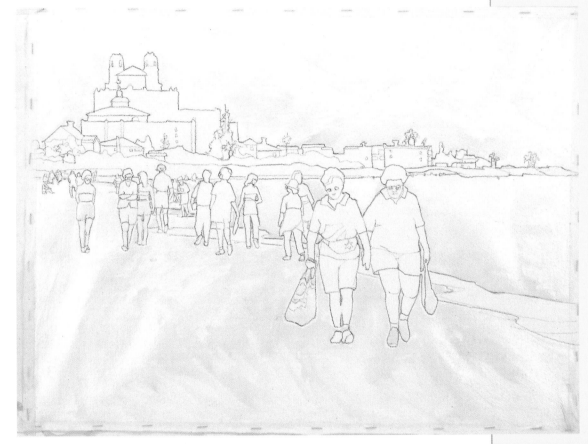

MASKING MAP

2 APPLY THE FIRST POUR

Always wet the paper first. If you forget to wet the paper, you'll have strange, hard-edged shapes. When the paper is wet, pour on the first layer of primary colors—first yellow, then red, then blue. You'll notice that the colors immediately begin blending into some exciting combinations. Let this first layer dry.

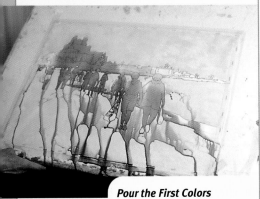

Wet the Paper

Pour the First Colors

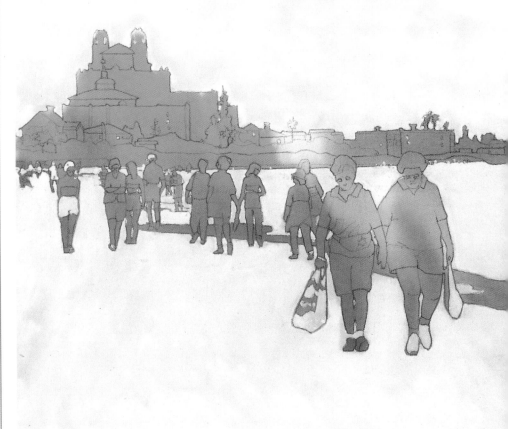

3 APPLY THE SECOND MASK

Add masking fluid to the areas you want to protect from the next pour. In this case, some of the areas worth masking are the two small buildings on the left, the shirts of the two closest figures, the house above them and some small areas on the other people. I also felt that the wet sand at the water's edge was getting too much attention. If this area becomes any darker, it will contrast too dramatically with the lighter, dry sand, so go ahead and mask that area. Leave a line of dry paper between the water and the wet sand to ensure the two layers of mask don't overlap. You don't want to accidentally pull up the water's mask when you lift the wet sand's mask, especially since the water stays white until the end.

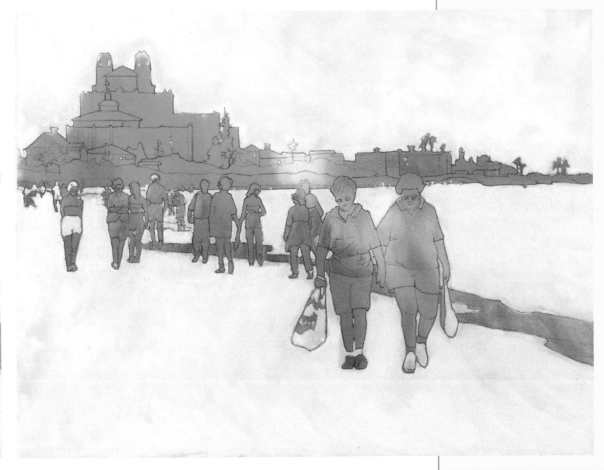

MASKING MAP

4 APPLY THE SECOND POUR

Wet the paper. Apply the yellow and then the red, letting them blend as they flow off the bottom. When the red and yellow no longer drip off the bottom, turn the painting upside down and apply the blue. Pour the blue so that it tints the middle and top of the painting. Let the excess flow off the top. To prevent backflow, don't lay the painting flat until the paint stops dripping.

Once everything is dry, turn the painting right side up again. You should be able to detect the value differences.

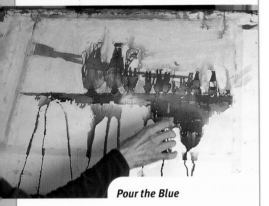

Pour the Yellow and Red

Pour the Blue

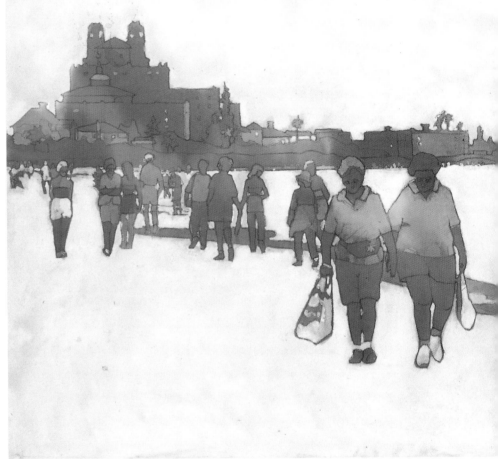

5 APPLY THE THIRD MASK

When the paper is completely dry, apply masking fluid once again. At this point, you should decide what shapes you'll protect from the third pour, like buildings or shapes on the figures. Don't remove any mask at this point.

The painting has now received three masks and two pours. All the pouring so far has gone on the shoreline, figures and the buildings in the distance. Notice how the three maskings cover a lot of the painting. This next pour will glaze color into the shapes of the figures and buildings.

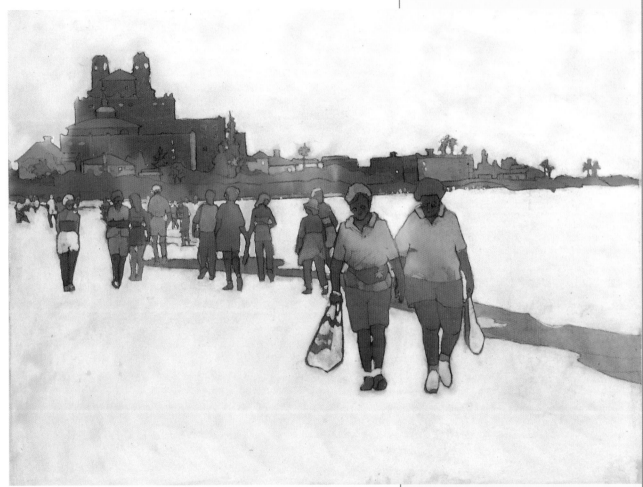

MASKING MAP

6 APPLY THE THIRD POUR

Check your paints to make sure they have been mixed thoroughly; there should be no specks or lumps when you pour. Wet the paper.

Since this is the last pour before the mask is removed from the large shapes of the sky and beach, I made it colorful. I poured all three colors, but used a little more red in order to warm things up.

After you've poured this third layer of color, take a good look at your painting. If you think you need another pour, apply it now before you remove the mask. This is your opportunity to flow color into any shapes you want darker.

Wet the Paper

Apply Color

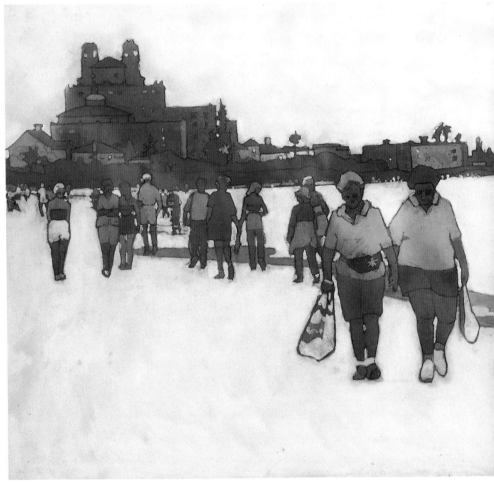

7 REMOVE THE MASK FROM THE SKY AND BEACH

In the next step, you'll tint the sky and beach, so go ahead and remove the mask from these areas, but leave the mask on the water.

As you peel the mask from the shoreline, you may need a razor blade to cut any areas that also pull up the neighboring mask on the water. If the mask does lift off, you'll need to reapply masking fluid. Make sure that the areas where you have just removed masking fluid are clean and free of all residue.

Separate the Neighboring Masks

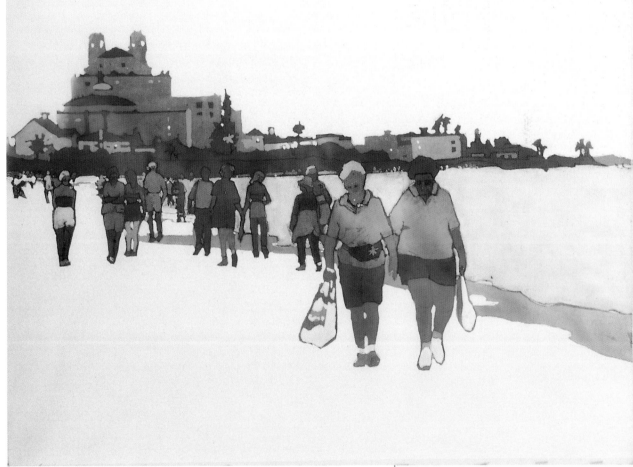

8 APPLY COLOR TO THE BIG SHAPES

Time to pour those big shapes you've been saving! Mix your three primary pigments. They should be lighter than the previous pours, but strong enough to give a glow to the painting. Always keep in mind how much lighter they will dry. Wet the paper *thoroughly*. I wash the paper down repeatedly, because the paint won't spread evenly if any masking fluid residue remains, and it's hard to see or feel. Since this painting is on a rough surface, the masking fluid is somewhat harder to remove completely.

As soon as the mask residue has been all washed off and while the paper is still wet, pour on those freshly mixed colors. Step back and observe as you pour. Will the sky glow more with another yellow pour? Have you captured the feel of twilight? As long as the paper remains wet, you can keep pouring until you're satisfied that you've reached your goal of a harmonious and unified painting. Let this dry.

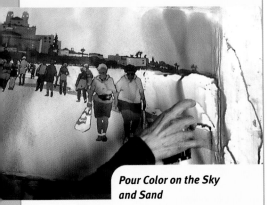

Wash Away Masking Fluid Residue

Pour Color on the Sky and Sand

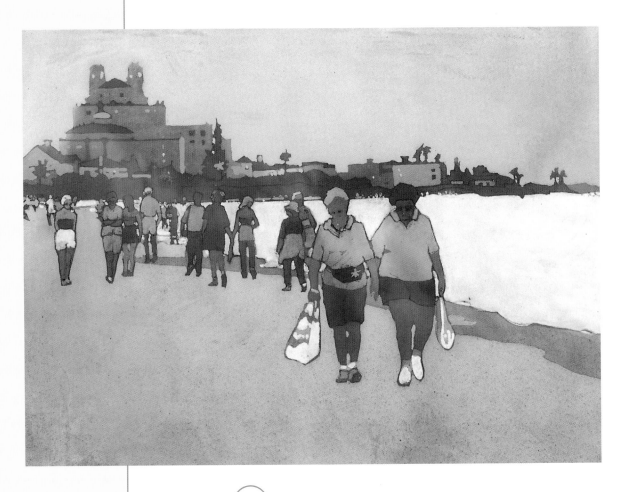

9 LIFT THE FINAL MASK

After the paper is bone dry, remove the last of the mask, including the mask on the water. Use the rubber cement pickup to avoid smearing the paint. Once the masking fluid is all up, you can see the whole value range of the painting and how powerful the white of the paper is. Note how the shirts that were masked after the first pour retain their glow.

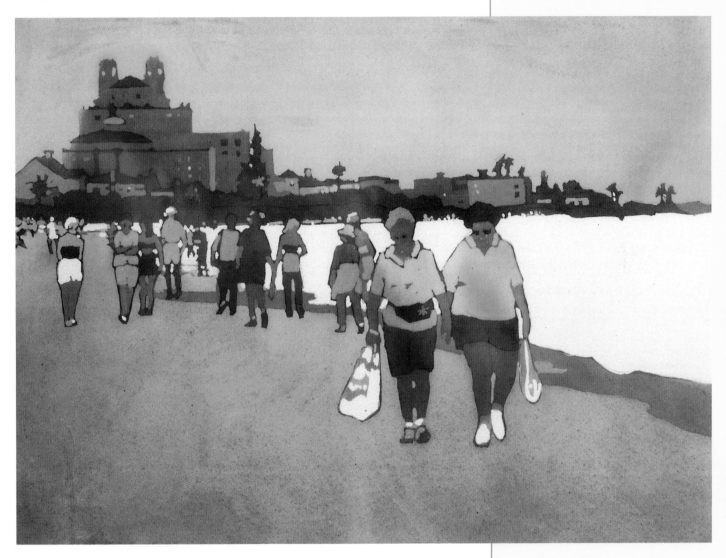

10 ADD DETAIL WITH DIRECT PAINTING

Time to put the frosting on the cake with some direct painting! Get out your favorite small round brushes (a no. 6 and no. 8 round work well), a small palette (I use a paper plate) and clean water. Onto the palette, squeeze out the colors you've been using for pouring. A small amount will do. Along with those colors, add Burnt Sienna to glaze flesh tones and Cobalt Turquoise Light to liven up dark areas.

A beautiful, clean dark can be made from the red and blue. To keep the colors vibrant, glaze warm over warm and cool over cool. To have less intense color, glaze warm on cool and cool on warm. For example, layering red on orange will keep the area bright. To mute a too-strong blue, glaze with the red.

At this point, I still may decide to pour one more time to lightly tint the water. For the purposes of this demonstration, however, I left the white paper.

Glaze With Direct Brushwork

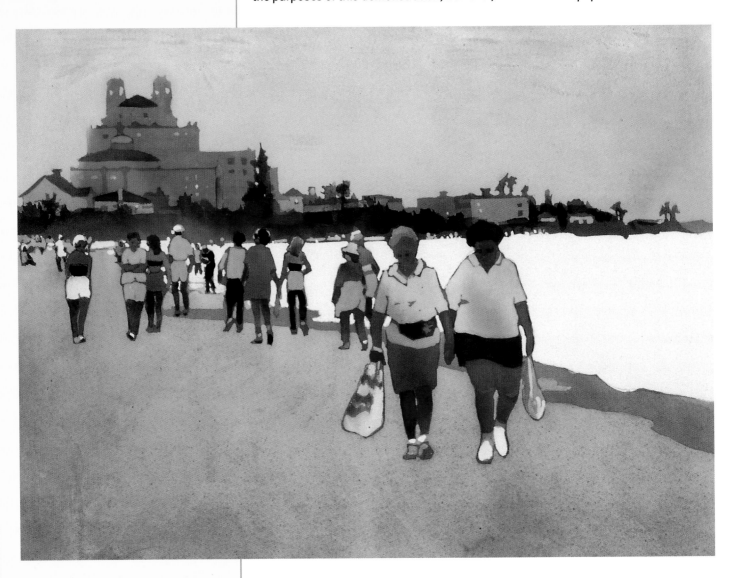

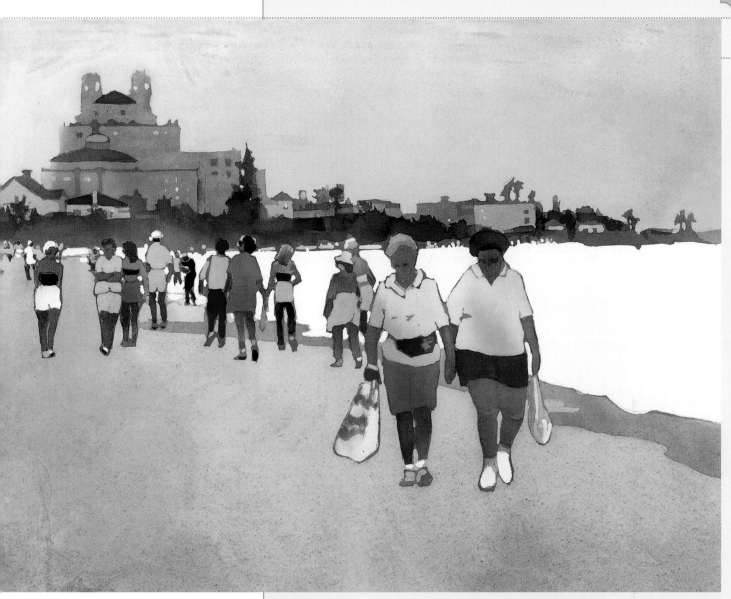

SHELL BEACH
15" × 21" (38CM × 53CM)
COLLECTION OF MARGARET CORNISH AND
EDMUND DEBARBA

DESIGN SUMMARY

The design pattern is a large and light midtone with an interlocking
wedge of a midsize white and small dark shapes.

A *dominance* of *cool colors* is visible in the clothing and distant trees. The whites in the water
and small shapes on the people are a *value contrast* to the darks and draw attention to the
people. Diagonal *shapes* give *direction* to the painting and direct the eye from the people to the
building. When the pours cover large shapes, they produce an overall *harmony* of *color*. The
blending produces a *gradation* of *color* that prevents boredom. *Warm colors* are repeated
in the buildings and people to create *harmony*. The simplicity of the large *shapes* and
their *values* goes a long way to *unify* a busy scene.

What could I do to improve this painting? I would probably work toward more *contrast* in the *size*
of the large shapes. The beach in the foreground could be expanded to make a bigger, better
shape. Perhaps it could be a darker *value*. As the beach goes back I might lighten the *value*
and cool the *colors* so it contrasts less with the sky. I might do the same with the building.
I left the water white to simplify this demonstration, but perhaps I'll assign it a *value* and
color temperature to *unify* it with the rest of the painting. I would definitely want to keep the
diagonal *direction* and the interlocking wedges of the *shapes* as they move into the picture.

Bike Break
Pouring Luminous Shadows

In order to see light there must be shadows. The contrast of the white sunny areas, the colorful midtones of the shadows and dark details make an exciting value range. By creating the cast shadows with the pours, the colors are harmonized and the painting becomes unified.

When I first thought about painting this bicycle in the midday heat, I included the cats resting in the shade. After completing the original painting, I realized that what really caught my interest was the bicycle. The pattern created by the strong sun on the tire tread was unusual and eye-catching, and the cast shadow offered a chance to simplify and strengthen the subject.

Look for opportunities to study and pour cast shadows. Set a plant or fruit in the sun and be sensitive to the colors and shapes of the shadows. It might be fun to leave off some of the plant or fruit and concentrate on the lights and darks of the shadow areas.

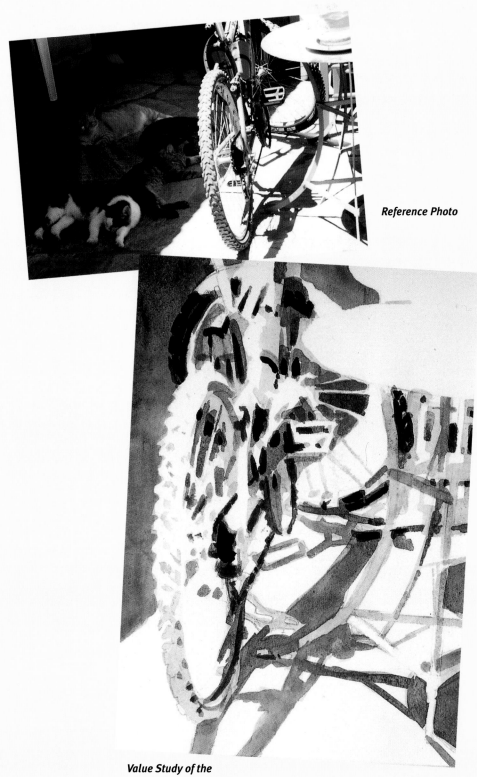

Reference Photo

Value Study of the Cropped Design

MATERIALS

General Materials listed on page 18

POURING PIGMENTS
Daler-Rowney Quinacridone Magenta
Daniel Smith Quinacridone Gold
Da Vinci Cadmium Yellow Medium
Da Vinci Hansa Yellow Light
Da Vinci Phthalo Blue
Da Vinci Red Rose Deep
Winsor & Newton Winsor Red

DIRECT PAINTING PIGMENTS
See Pouring Pigments

1 APPLY THE FIRST MASK

First, transfer your drawing to the stretched paper. After making sure that the paper is thoroughly dry, apply the first mask. This is an important step, so refer to the value study to determine which areas need to be masked. It might help to think that you want to save any areas where light hits. This painting has lots of light areas, so you're going to be busy with the masking brush. Remember to keep the brush wet and soapy so it stays slick and clean of masking fluid. This first mask is the most influential, so apply it with care. After the first mask is dry, give the large shapes another coat of masking fluid to prevent any pinholes or paint leakage. This first mask is difficult to see, but it does have a slightly yellow cast when it dries.

Apply Masking Fluid

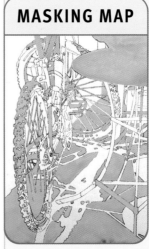

MASKING MAP

2 POUR THE FIRST COLORS

Mix and test your paints before you start. In this pour, the colors are Hansa Yellow Light, Cadmium Yellow Medium, Red Rose Deep and Phthalo Blue. Because I wanted a warm undertone, I used two yellows to help them hold their own with the Phthalo Blue and Red Rose Deep. The Phthalo Blue is one strong character, so mix it with lots of water. When you're satisfied with your mixes, wet the paper to create a layer of water for the paints to flow over.

 Tilt the painting so the paint runs off the lower right corner and into your bucket. Pour the two yellows first, followed by the Red Rose Deep and Phthalo Blue. Once the initial colors are laid down, you can adjust them by pouring more color until you are satisfied with this pour. Let this dry.

Wet the Paper

Pour the Colors

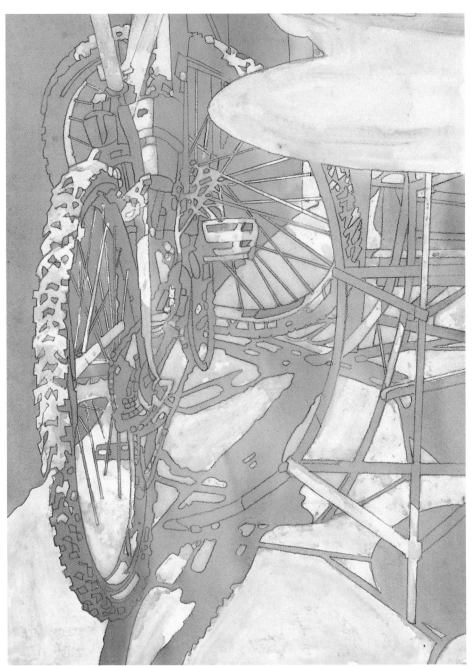

3 PROTECT THE LIGHTER VALUED SHAPES

Use the masking brush only after the bristles are dipped in water and then soaped to protect it from the masking fluid. The value study will again help you determine what shapes to cover. Since you've already saved the whites, you want to cover the shapes that will stay the value of the first pour, like the rear and front wheels and some of the table legs. If you'd like any areas to be pure red or yellow in the final painting—like the water bottle, the pedal reflectors, the background table leg—cover those now. Let everything dry.

Apply the Second Mask

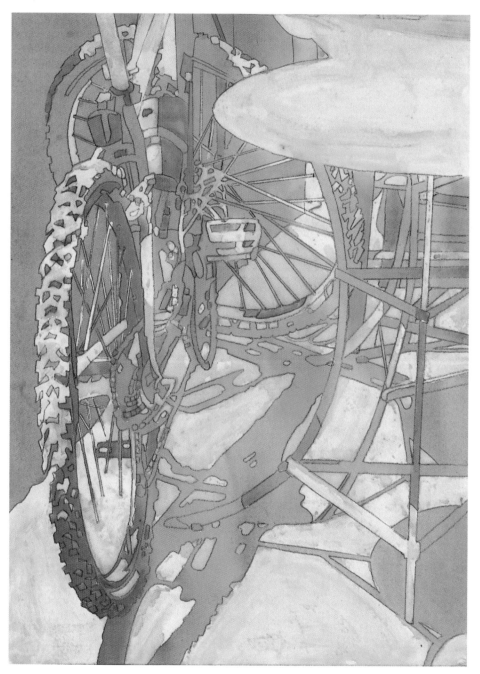

MASKING MAP

4 APPLY A SECOND POUR

After the second mask is dry, wet the paper. As always, don't forget to wet the paper. Once the paper is wet, it's time for the second pour. Did you mix the paint stronger than the first pour? You really need to go darker, but not so dark that you're pouring the darkest values; this pour is for the midtones.

You may want to vary the colors in this second pour as I did. I felt confident that I'd have a variety of value if I stuck with pouring the primaries, but I felt a need for a variety of hue as well. The shapes are a bit small and would have become a bit boring with the same colors used over and over.

The colors I used in this second pour are the Phthalo Blue, Cadmium Yellow Medium, Winsor Red, Quinacridone Gold and Quinacridone Magenta. Each color serves a different purpose in the painting. The Winsor Red—a rich, heavy-bodied color with a tomato hue—I poured wherever I wanted to reinforce the warms. The Quinacridone Magenta is a clean transparent color that makes a wonderful dark, warm red-violet. The Quinacridone Gold has the ability to stay transparent in thicker mixtures where other yellows would become opaque.

Wet the Paper

Pour the Color

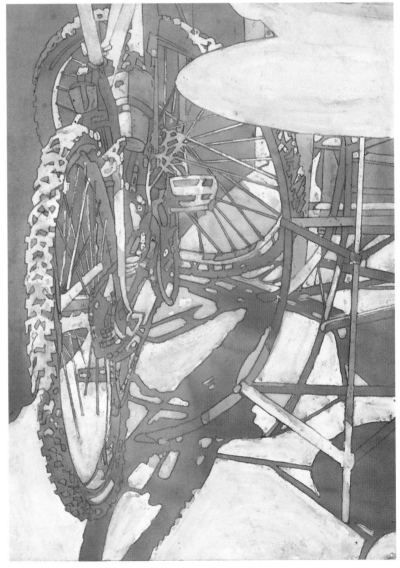

5 APPLY THE FINAL MASK

After the painting is totally dry, it's time to add some more masking fluid. Again, refer to the value study to determine what shapes to save. Some of the table legs and parts of the bike should be protected from the last, darkest pour. Let the masking fluid dry.

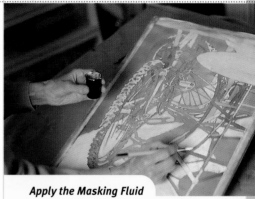

Apply the Masking Fluid

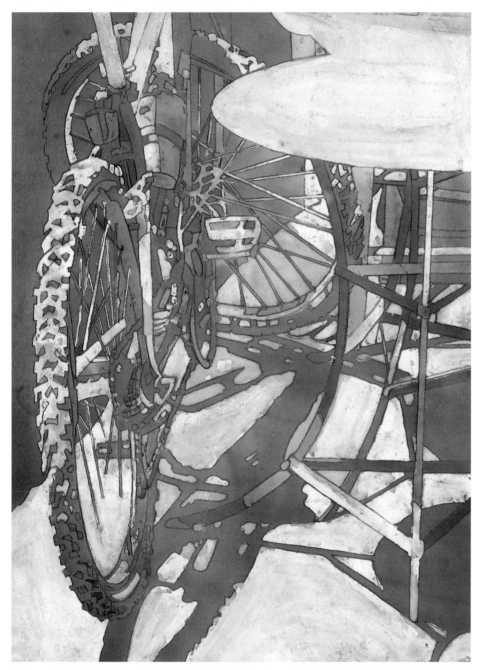

MASKING MAP

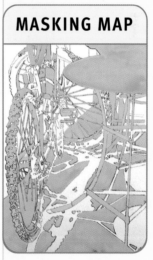

6 POUR THE LAST POUR

Before the last pour, don't forget to wet the paper. (I told you that I would remind you!) For this pour, have a variety of colors mixed: Red Rose Deep, Phthalo Blue and Quinacridone Magenta. Since this pour consists of dark values, don't mix any yellows; adding yellow at this point would only create a chalky drift across the painting. Mix the pigments carefully, using less water than for the previous pours. Make sure you pour only thoroughly mixed paints. If you aren't diligent, the result could be a pour with lumps of pigment. This is difficult to cure, so an ounce of prevention pays off in a more stress-free and beautiful painting.

For the most part, concentrate the warm colors in the middle of the painting where the bike is and keep the cool colors on the sides. That said, it's also important to add a little warm to the cool side and cool to the warm parts.

Let the deep rich colors blend and flow. Tip the painting on its side when you pour the cool colors to let the excess drain off either the left or right side. Use gravity to direct the flow. Let this dry.

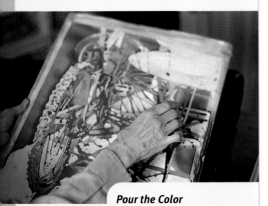

Wet the Paper

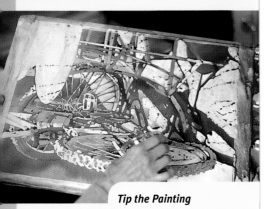

Pour the Color

Tip the Painting

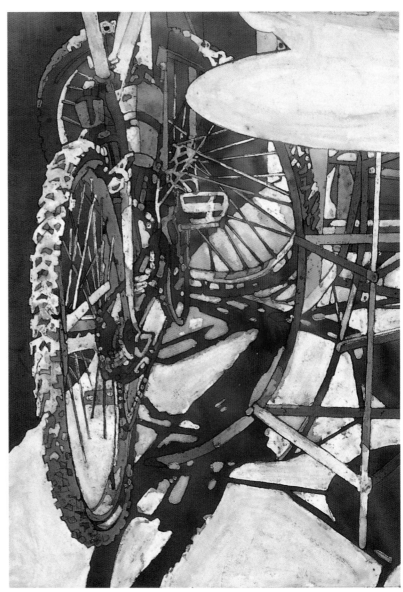

7 REMOVE THE MASK

Remove all of the masking fluid. Use a rubber cement pickup or raise a corner of the mask and peel off the entire mask with your fingers. Keep your hands clean and avoid smearing the paint onto the white paper. Make sure you've removed all the mask.

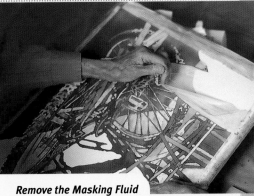

Remove the Masking Fluid

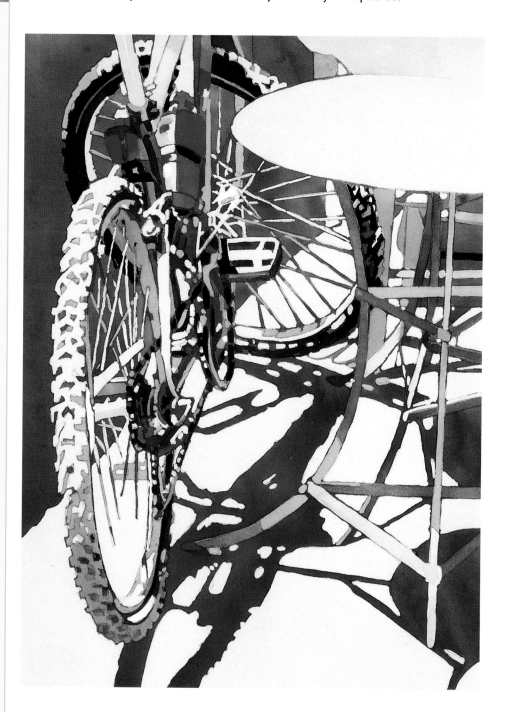

8 PAINT DIRECTLY WITH BRUSHES

Bet you're anxious for the final touches! Arrange fresh paints on your palette or a paper plate and have your no. 6 and no. 8 rounds ready. For these final dark, colorful shapes, use juicy paint right from the tube. Paint the rear reflector light and water bottle Winsor Red. For the table legs, tires and the pedal reflectors, use Cadmium Yellow Medium. For areas with an orangier hue, mix these two colors. Mix Phthalo Blue and Red Rose Deep for the dark areas on the front wheel and chain. For the various greens, mix different amounts of Phthalo Blue and Cadmium Yellow Medium. Phthalo Blue also works well with Quinacridone Magenta for the rich, warm darks. This step is easy to overdo, so take it slow and easy. Leave the cast shadows just as they were poured.

Apply the Paint

DESIGN SUMMARY

The design pattern is a large, light diagonal shape and a smaller shape that is a dark diagonal. The light shape is intersected by a smaller dark shape, and the dark shape is interlocked with a smaller light shape.

The circular shape of the bicycle wheels, tabletop and legs is a *repetition* of *shape* that really *unifies* the painting. A strong *contrast* of *value* exists between the light and shadow. *Gradation* of *color* helps vary the darks. There's a *variation* in *color* between the cool legs of the table and the warm bottle and lights of the bike. The *direction* of the *movement* through the painting has a *rhythm*: from the foreground shadow to the table leg to back wheel, then down the back wheel and out of the painting. When working with a vertical subject in a vertical format, use strong diagonals to carry the eye through the piece.

What would I change in this painting? I don't know. At this point, I'm pretty content with how it looks. My intention was to portray the sun and shade of this hot day in Greece, and this painting certainly takes me back!

BIKE BREAK
20" × 14" (51CM × 36CM)
PRIVATE COLLECTION

CONCLUSION

CONCLUSION IMPLIES AN END, AN EXIT, A CLOSING. It can also denote a passage toward a victory and mastery after a struggle. I'd never wish a struggle on anyone, but I do hope you've mastered some new techniques.

I also hope you've won the confidence to be innovative without the fear of failure. When you begin asking yourself, "What would happen if I...?" instead of "Is it okay to...?" then you know you're there. There is no right or wrong. A better or easier way to approach a problem may exist, and the world is full of unique solutions. The only failure is failing to try something. Persistence, stubbornness and patience are as much a part of success as talent.

■ SETTING GOALS ■

Setting both long-term and short-term goals is important. This keeps us focused as we become more skilled in the ways and quirks of watercolor. First we learn to paint, and this gives us a vocabulary. Then we are free to use this vocabulary to tell our story. Along the way we develop our own style. This happens as we use our personal concepts and deal with the compositional issues that will result. Style is as individual as your DNA. By sketching and painting and painting more, style will come.

Short-term goals may include learning to use a specific technique or material or resolving a conceptual problem. In the long term, you will want to become less interested in pleasing your family, friends and art show jurors and more involved in self-expression. The evolution of your art personality will take time, study, courage, persistence and hard work. The effort will provide the joy of achieving the most important goal—a self-knowledge backed by the study of sound art principles.

SANTORINI
30" × 22" (76CM × 56CM)

POURING FAQ

I'VE DECIDED TO INCLUDE A LIST OF QUESTIONS I'M MOST FREQUENTLY ASKED IN WORKSHOPS.

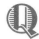 If I can purchase just the most basic supplies, what would you recommend for pouring?

If they're available, pick up the large 37ml tubes of paint. The three primaries of Da Vinci Phthalo Blue, Red Rose Deep and Hansa Yellow Light or the Winsor & Newton Winsor Red, Yellow and Blue will start you off right. You'll also need three mixing cups and a tub to pour into. You need paper, staples and (naturally) something to staple your paper to. Gator board works well, but whatever you choose, make sure it doesn't warp and can take staples. A spray bottle is always a welcome tool. Start simply and add materials as your work progresses.

 Should I use a certain brand of masking fluid?

No, you can try any masking fluids on the market. I've grown to like the Incredible White Mask, but you may prefer another brand. Make sure you test a masking fluid before you apply it to your painting.

 Can I use some of the paper I have on hand instead of Arches?

The best answer to that question is "Try it!" Stretch it on a board and let it dry. Make some shapes with masking fluid and pour away. I have poured on illustration board, gessoed surfaces, bristol board and canvas. Some of the softer papers will tear when the mask is moved.

 Can I pour acrylics?

Why not? If it's thin enough, you can pour it. Be aware of the consequences and limitations of acrylic paint, though. For instance, acrylics are difficult to lift after they dry. Also, you won't have the same blending of color you have with watercolor.

 How do I get rid of all the hard edges?

The repeated masking and pouring usually prevents hard edges. The final steps of direct painting and glazing usually help, too. If hard edges remain, one thing I do is remove the painting from the board and lay it in a filled bathtub. Once it's submerged, I gently rub the hard edges with my fingertip. This lifts the color. (A bath can also help bring life back to a painting by removing excess paint.) When you're satisfied, staple the damp painting back on the board so it will dry flat. In less drastic cases, a damp sponge can be used.

 Can I pour *before* applying masking fluid?

Absolutely. If you're careful about keeping light shapes in the painting, this soft underpainting is a wonderful way to start. Of course, to keep the underpainting soft and free of hard edges, you need to make sure the paper is wet before you pour.

 Can I leave the masking fluid on permanently?

A permanent masking fluid is available from Winsor & Newton. It's meant to stay on the painting and can be tinted or remain a warm, creamy color. Normal masking fluids, however, must be removed when the painting is completed. If they're left on too long, they become a sticky, gummy mess and can bond to the paper.

TALIESEN GUIDE
20" × 28" (51CM × 71CM)

 Can I enter paintings with gouache in watercolor exhibitions?

The best policy is to finish the painting, using whatever materials are needed. Then read the prospectus issued by the sponsoring organization. Each show will have its own criteria. Some admit only transparent watercolor. Others will allow opaque mediums and restrict collage and pastels.

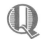 Can I work from other people's photographs?

Why would you want to? You have less emotional involvement with someone else's photo. A small thumbnail sketched on-site would have more to offer than another person's choice of photographic material. Use your own photos in conjunction with your sketches and the painting will truly be your own.

Besides all this, using someone else's photo can cause legal problems. If you plan to sell, publish or submit the painting to a contest, use only your own photos.

Using another's work as practice is generally considered acceptable, but it can hinder your development as an artist. The choice of the subject and the arrangement of a composition is a large part of being an artist. Why would you give that up?

Index

GOATS ON SKOPELOS
8" × 21" (20CM × 53CM)

LOOK FOR THESE OTHER GREAT TITLES FROM NORTH LIGHT BOOKS!

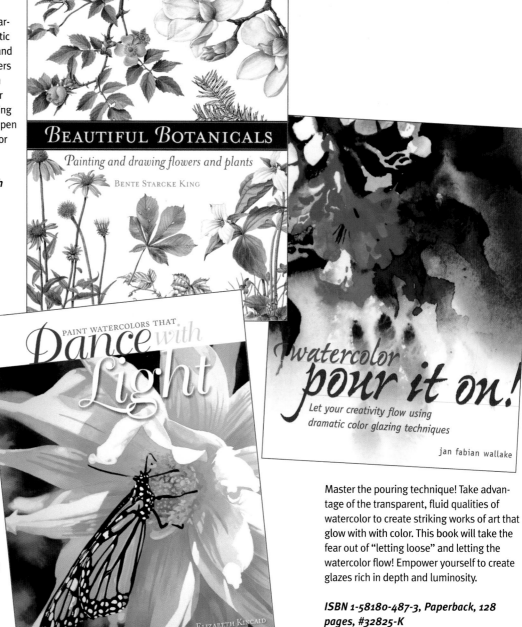

Let acclaimed botanical artist Bente Starcke King show you how to create realistic illustrations of tulips, irises, rose hips and more. Fine artists and decorative painters alike will find clear, detailed instruction and 19 step-by-step demonstrations for creating realistic flowers and plants using a variety of mediums, including pencil, pen and ink, ink wash, transparent watercolor and mixed media.

ISBN 1-58180-494-6, Hardcover with wire-o, 128 pages, #32840-K

Elizabeth Kincaid invites you to follow her proven techniques for painting dazzling scenes drenched in color. Her beautiful flowers, foliage and landscapes will have you eager to create your own—and you will! The easy-to-follow step-by-step instructions take the mystery out of composition, color, light and shadow and offer a practical guide to masking and glazing. Your newly trained eyes will be able to visualize before painting and better perceive abstract form, value, line and color.

ISBN 1-58180-468-7, Hardcover, 128 pages, #32731-K

Master the pouring technique! Take advantage of the transparent, fluid qualities of watercolor to create striking works of art that glow with with color. This book will take the fear out of "letting loose" and letting the watercolor flow! Empower yourself to create glazes rich in depth and luminosity.

ISBN 1-58180-487-3, Paperback, 128 pages, #32825-K

THESE BOOKS AND OTHER FINE NORTH LIGHT TITLES ARE AVAILABLE FROM YOUR LOCAL ART SUPPLY STORE, BOOKSTORE, ONLINE SUPPLIER OR BY CALLING 1-800-448-0915 IN NORTH AMERICA OR 0870 2200220 IN THE UNITED KINGDOM.